A Good Book, In Theory

A Good Book, In Theory

A Guide to Theoretical Thinking

ALAN SEARS

broadview press

Library and Archives Canada Cataloguing in Publication

Sears, Alan, 1956–
 A good book, in theory : a guide to theoretical thinking / Alan Sears.

Includes bibliographical references and index.
ISBN 1-55111-536-0

1. Sociology—Philosophy. 2. Critical thinking. I. Title.

LB2395.35.S42 2005 301'.01 C2004-907328-1

Broadview Press, Ltd. is an independent, international publishing house, incorporated in 1985. Broadview believes in shared ownership, both with its employees and with the general public; since the year 2000 Broadview shares have traded publicly on the Toronto Venture Exchange under the symbol BDP.

We welcome any comments and suggestions regarding any aspect of our publications — please feel free to contact us at the addresses below, or at broadview@broadviewpress.com / www.broadviewpress.com

North America
Post Office Box 1243,
Peterborough, Ontario,
Canada K9J 7H5
Tel: (705) 743-8990
Fax: (705) 743-8353
customerservice
@broadviewpress.com

3576 California Road,
Orchard Park, NY
USA 14127

*UK, Ireland, and
Continental Europe*
NBN International
Estover Road
Plymouth, Devon PL6 7PY
United Kingdom
Tel: +44 (0) 1752 202300
Fax: +44 (0) 1752 202330
Customer Service:
cservs@nbninternational.com
orders@nbninternational.com

*Australia and
New Zealand*
UNIREPS
University of
New South Wales
Sydney, NSW, 2052
Tel: + 61296 640 999
Fax: + 61296 645 420
info.press@unsw.edu.au

Broadview Press Ltd. gratefully acknowledges the financial support of the Government of Canada through the Book Publishing Industry Development Program for our publishing activities.

Edited by Betsy Struthers.
Cover design and typeset by Zack Taylor, www.zacktaylor.com.

Printed in Canada

Contents

Acknowledgments

THIS BOOK is dedicated to Ken LeClair, Happy 20th! Thanks to Anne Brackenbury from Broadview Press, who helped nurture this book from the outset through discussion and editorial comment. Conversations with Anne Forrest, Ken LeClair, Veronika Mogyrody, and Charlene Senn helped fuel the development of this book. Betsy Struthers was a very helpful copy editor, clarifying the text in crucial ways. Finally, thanks to the many students over the years who have challenged me to improve my teaching by engaging seriously with the materials at hand. A few of these include: Kathy Gordon, Lowell Hall, Kevin Panton, Steve Rathbone, Steve Richardson, Elsa Silva, Danielle Soulliere, Dustin Soulliere, Pasha Stennett, and Cheryl Thompson.

Preface

*Users' Guide for Students
and Instructors*

I ADMIT IT: I am one of those people who never reads instructions when I buy something new. I just plunge in impatiently and try to figure it out on the go. So I understand if you skip this brief introduction and just get right into the book. There are times, however, I wish I had been a bit more patient. Sometimes there are useful things to learn from the instructions.

Of course, books usually do not need a users' guide. You just open them up and start reading. This book is, however, rather different from most of the theory texts that are available, so I thought it might help to say a bit about why I wrote it and how it might be useful.

This task is a bit tricky because there are two groups of users for this book: the students who read it for a course and the teachers who use it as an instructional tool. I have tried to aim this Preface at both groups, but that means that some parts will be addressed more to one than the other.

FOR THE GENERAL AND STUDENT READER

I HAVE BEEN teaching compulsory theory courses for over 15 years. Students have to take these courses to meet the requirements for their degree. Over time, I have become convinced that I am doing something wrong. The students forced to take my courses have told me in written evaluations that I did a fairly good job of making dry material somewhat interesting. But I do not believe I convinced most of them that there was a very good reason for these

theory courses to be compulsory. I did not succeed at developing their appetite for theoretical thinking or convincing them that it could be useful in their futures.

In retrospect, I realize that my general approach has been to introduce students to a set of social theories without ever providing any guide to theoretical thinking itself. As a result, my students drew on their prior educational experience and tried to approach theories in a fact-like way, learning by rote, for example, that Marx wrote about class struggle and Durkheim about the division of labour. But the courses did not equip them to understand why that distinction might matter. A small number of students worked it out for themselves, while many others never saw the usefulness of theory courses.

My own experience helped me identify this problem. I took five years off between getting a three-year B.A. and returning for a fourth year before applying to graduate school. I got really nervous when I returned to classes because I had retained virtually nothing. I could remember vaguely, for example, that Durkheim and Weber both did comparisons of Catholics and Protestants, but beyond that did not have a clue about their major contributions. I was afraid that I was entering fourth-year courses with almost no memory of the prerequisite courses I had taken along the way.

I realized pretty quickly that the specific, detailed content of the courses I had already taken was not that important as it was fairly easy to relearn. I had learned something in my first three years of university, but it was not the detailed content. Rather, I had developed an approach to learning that included methods for reading, writing, analyzing texts, listening to teachers, and engaging in discussion. Those methods were more important to my survival in fourth year than the facts I had memorized for exams and forgotten long ago, usually within moments of completing the final.

This book sets out a different approach to teaching and learning theory. The focus here is on the method of theoretical thinking rather than the specific details of various schools of social thought. Theoretical thinking begins with the everyday

theorizing we all do to make sense of the world around us. As we go through our lives, every one of us develops working assumptions based on various forms of generalization from our experience that we use as a guide to the situations we face. Without that, we would be completely at sea when we confront anything new or different.

These generalizations are based on our ability to distinguish the aspects that are specific to a particular situation from those that are more likely to recur. One time a bug crawled out of a piece of pie I was eating in a restaurant. I did not want to repeat this disgusting experience. As a result, I had to figure out the general pattern of bug appearance so that I might alter my behaviour to reduce the possibility of this recurring. I could generalize that pies are likely to be bug-infested, and avoid pie for the rest of my life. Or I might assume that the restaurant had hygiene problems, and avoid that one place. We learn to identify the features that define a particular phenomenon as exceptional rather than as a part of a more general trend.

The generalizations we develop through our everyday theoretical thinking are extremely useful, but tend also to be limited in their power as they draw only on our own insights and what we have gleaned from others. The formal theories developed in scholarly study and through social movement activism often have a penetrating power as they reflect a broader view developed through interchange over time and a more rigorous set of requirements for internal consistency and fit with the world.

This book illustrates some of the power of these more formal theories with reference to issues in our surroundings. The aim is to show how the world we already know can look very different through the lens of particular theories, just as looking through binoculars can provide new insights on a hike through the woods. It is a guide to theoretical thinking, which is one important and often neglected dimension of theory education. The aim is to help students to develop a method that will assist in making sense of the specific theories they will be exposed to through their education by

relating it to students' own activities in the world. It builds on the foundation of the everyday theorizing we all engage in all the time. It includes exercises at the end of each chapter that might help animate discussion by encouraging people to apply new theoretical insights to their everyday experiences. The tone is a bit more chatty and informal than in most theory texts. The aim of the book is to complement rather than replace other texts that provide a detailed introduction to specific theorists and schools of thought.

My interest in theory education stems from my conviction that theoretical thinking is extremely useful in the world. Theory might seem to be the most obscure and academic of subjects, particularly given the specialized vocabulary that is difficult to penetrate and the big concepts that can seem pretty far removed from reality. Yet, it can be practical, providing vital insights that allow us to make sense of the world around us and serve as a guide to action when we try to do something about the things we would like to change.

Theory provides us with visions of the world that go well beyond the comprehension we are able to develop through our daily activities. Malls, for example, have become major fixtures in the lives of many of us, whether for work, shopping, going to movies, hanging out, or eating there. Different theories allow us to see the growth of the mall over the last 50 years as one of a series of interrelated changes that have had a huge effect on our leisure, work, and political activities.

Leisure activities have tended to become much more dependent on the consumption of products we buy rather than on the things we do and create on our own or for each other. Music, for example, is something we experience mainly through recordings. Birthday parties are increasingly held at fast food restaurants or activity centres rather than at home. Shopping has become a leisure activity in its own right, rather than a means to an end (the actual purchase of something you need).

Contending theories provide very different explanations for these changes, which might be taken as signs of a generally affluent society where most people now have access to

considerable wealth or of the spread of consumerism that means that our self-worth is increasingly defined by the products we can buy. Each of these theoretical perspectives will highlight certain aspects of the phenomenon under consideration and, at least by implication, suggest certain forms of action. Should you sign a petition against the arrival of a new Walmart in town or rush out to enjoy new access to cheaper products? Your theory of shopping in our current society will have something to do with your response.

FOR THE TEACHER OF THEORY

THEORY TOO often is taught in a highly academic form, sealed off from the everyday world. I, too, have generally taught theory courses without any real connection to practical activity or the lived experiences of my students. As a result, theory courses from a student's perspective do not seem essential even if they are required.

I wrote this book as a tool to assist in teaching theory differently. The book can be used as a jumping-off point at the beginning of a theory course, developing an appetite and aptitude for theoretical thinking before facing the challenge of handling the complex theories written by the big names. Alternatively, various chapters could be scattered through the course, creating a back-and-forth pattern between the study of formal theories written at a high level of abstraction and a more grounded approach to theoretical thinking.

The book uses one theoretical debate—between the social order and conflict models of theory—to demonstrate the importance and vitality of theoretical analysis. I selected this particular debate as it closely parallels key themes in contemporary discussions of social and political issues, ranging from moral values to work processes, from social welfare to the status of women. I do not claim this exhausts the field of theoretical interchange, but I hope that using a more simplified debate format to introduce students to theoretical thinking

will allow them an entry point into what is sometimes an overwhelming array of theoretical choices. The aim here is to prepare students with a strong base from which they can negotiate the complex and disputed terrain of contemporary social theory.

I also believe this book can be useful in courses not focused exclusively on the study of social theory. In introductory courses, it can challenge students to think of disciplines as ways of seeing the world rather than massive vaults piled high with collections of facts accumulated in previous research. The goal is to get students to begin to use disciplinary perspectives to frame their own analysis of the world around them, so that they can begin to understand the practical value of the subjects they are studying in illuminating their environment directly or indirectly.

I also see a need for a better bridge between theory and methods courses. It is my sense that we do not make it easy for students to understand the role of theory in the research process. Sure, we might offer some formalized statements about beginning with hypotheses derived from theory, but nevertheless we tend to present research methods as a technical problem quite distinct from theoretical thinking. This book could be used in theory or methods courses to make that link, suggesting that theoretical thinking is impoverished without rigorous research and that even the most technically perfect research project will yield little without an analysis ground in powerful theoretical insights.

This book could also be useful in assisting students to understand the importance of theory in substantive courses. I find students often consider theory an intrusion in a course on crime, international development, or labour studies. They often hope for an unbiased perspective that will shed light on a particular area of our social existence. It is my sense that we often fail to explain the importance of theoretical analysis in studying various subjects. Theoretical thinking frames our view of the subject, whether we are conscious of our presuppositions or not. This book encourages self-reflection as a

necessary tool to become more aware of our own presuppositions and analysis in order to figure out those of others.

I hope that this book helps students see theoretical thinking as the development of something they already do rather than an alien activity they can never master. Thus, the book may be useful in a variety of courses. The ultimate goal is to help students assume a more active role in their own education, seeing the things they learn as the development of their own aptitudes rather than as something external that they are forced to try to assimilate.

To that end, I have put set of exercises at the end of every chapter designed to encourage practical reflection on the issues at stake. The aim of these exercises is to make the major concepts discussed in the chapter more three-dimensional by exploring the ways they work or do not work in the everyday world. These are the equivalent of lab exercises in science, where you actually see with your own eyes the phenomenon you are studying.

Every chapter except the first also has an activity and/or debate aimed more at developing methods for working through formal theories. The activity follows two sample arguments that build on the chapter's content, one reflecting a conflict and the other a social order orientation. I explain these terms in depth in Chapter 1, and the goal of the activities in the subsequent chapters is for students to relate the two sample arguments back to the initial discussion of these two models. The arguments are not specifically identified as conflict or social order, so the reader must figure out which model it belongs to and, most importantly, explain why it fits there. The aim of these activities is to encourage a method of understanding theories by learning to seek out the underlying premises and perceiving the way those are presented in a particular position.

The activities are designed to help develop skills at reading theory and writing on theoretical topics. The focus is on the ability to understand the ways that the various assertions and positions in theoretical writing can be linked to the core premises that underlie the whole approach. The exercises are

designed to encourage the application of these theoretical concepts to practical, everyday experiences to show how useful they can be.

IN PARTING

I HOPE YOU have fun with this book. I think theory is a hoot. Sure, some of the reading is hard and maybe even tedious at times. Still, theory can be exciting because it allows us to be surprised by a world we thought we already knew. It makes us think in depth about cooking or football, work or fast food. This book is designed to help you play with theory, using it the way a fun house mirror makes the familiar strange. These effects can be disturbing, as you see yourself and your everyday world reflected back in ways that seem distorted and off-putting. This discomfort is a necessary part of the process that leads us to learn by inquiring about the circumstances that shape our experiences.

Anthropologists use the term "culture shock" to describe the sense of dislocation that comes from being immersed in an unfamiliar setting. They seek out such experiences rather than avoiding them, even though they may be very painful. We can be enriched by stretching ourselves to understand things that might at first seem threatening because they are different from what we might have expected. Theoretical thinking can produce a kind of culture shock when looking at ourselves and our surroundings. It allows us to know our familiar world in new ways.

I

An Interesting Idea,
In Theory

THEORY HAS a bad reputation. It can seem rather useless and is often very hard to understand. Indeed, the words "in theory" are often used to describe idealized thinking that does not fit with reality. For example, in the play "The Bald Soprano" by Eugene Ionesco (1958: 22-23) two English couples, the Smiths and the Martins, are sitting around chatting. The doorbell rings twice. Each time, Mrs. Smith goes to the door and returns to announce that no one is there. Then it rings a third time.

Mr. Smith asks his wife to answer it. But Mrs. Smith says she will not. "The first time there was no one. The second time, no one. Why do you think there is someone there now?"

Mr. Smith explains, "As for me, when I go to visit someone, I ring in order to be admitted. I think that everyone does the same thing and that each time there is a ring there must be someone there."

Mrs. Smith responds, "This is true in theory. But in reality things happen differently. You have just seen otherwise."

This is a wonderful summary of common everyday assumptions about theory. Trust your senses; what you *see* is the *real* truth. The idea that someone must be at the door if the bell has rung is only true *in theory*, in an idealized system of thought that does not necessarily correspond to reality.

I have written this book to convey my enthusiasm for theory and challenge its bad reputation. Theory is not simply an obscure mind-game played by clever academics who have nothing better to do with their time. In fact, theoretical

thinking is absolutely essential to our daily lives. Richard Hyman (1975: 2) argues that people cannot act without theory, "for theory is a way of seeing, of understanding, and of planning." At its core, theoretical thinking is about generalization, relating a new situation to an old one in order to discern patterns and figure out what is likely to happen.

Both Mrs. and Mr. Smith used theoretical thinking in "The Bald Soprano." Mr. Smith developed a general law of doorbells from his own experience: "Each time there is a ring, there must be someone there." A bit later in the scene, Mrs. Smith derived her own general law: "Experience teaches us that when one hears the doorbell ring, it is because there is never anyone there."

The Smiths' theoretical thinking is essentially practical—it guides them to action when the doorbell rings. It is grounded in their immediate experience. It is also flawed, in that they both construct a universal rule to cover all circumstances out of a very narrow base of experience. Of course, we all do this frequently and then refine the broad generalizations when they do not fit reality. We also supplement these generalizations from our own experience with things we learn from others, either in the form of anecdotes that relate snippets of their experiences or as theoretical statements, whether formal or informal.

Unfortunately, the study of formal theories within academic disciplines usually makes no connection to this practical everyday theorizing that is grounded in experience. Instead, the study often begins with the complex and powerful theories that have been developed in various disciplines over generations. The reference point for such study is often other theories, rather than experience. Students might learn to distinguish Karl Marx from Max Weber, but may not learn why that distinction matters.

I have taught theory courses for many years now and have been increasingly convinced that I am doing something wrong. I love theory because it is so useful in acting on the world. I believe it helps us gain power over the world by providing us with insights for understanding the way things

work. Yet as a theory teacher, I fear I have generally failed to convince my students that theory is useful in any way. The formal theories I teach seem to have nothing to do with the everyday understanding of life that we all use to guide our activity.

My aim in this book is to show that theory is useful by using it to shed a new light on everyday experience. I want to help you to use theoretical thinking to examine your environment and your own assumptions in new ways. In the next chapter, we will begin right where you are by looking at the classroom and its social relations. Then, in Chapter 3, we will look at the real world you might assume exists outside of the ivory towers of academia. Chapter 4 will look at ideas about nature in contemporary society. In Chapter 5, we will look at the way theoretical work casts light on the use of time in our everyday lives.

I have chosen these topics to map a route that proceeds from where you are to the very broad generalizations that are the building blocks of formal theorizing. The book is designed as a series of theoretical questions that follow one another. Why is the classroom organized this way? Why do I assume the "real" world is beyond the walls of the classroom? Why does this relationship between the classroom and the "real" world seem natural, so we assume this is just the way things are? Is the passage of time the most natural of all human experiences, or is it socially constructed in very different ways in various societies?

In this way, I set up a dialogue between the everyday theoretical thinking you have already done about these topics and the formal theories associated with academic disciplines. I will try to convince you that these formal theories are worth getting to know, even if they play hard to get and seem to have no social skills. Everyday theorizing is the crucial basis for all theoretical thinking, but, as we shall see, it can be enriched by engagement with the formal theories that have been developed over time.

THINGS FALL DOWN, IN THEORY

C HANCES ARE you already know some-
thing about the laws of gravity. You know which way that
precious but ugly vase that was once your great-grand-
mother's will go if it slips from your hands. You probably
know also the name Isaac Newton. In the folk myth about
Newton, he was sitting under a tree one day when an apple
fell on his head. Being a great thinker, he generalized this into
the law of gravity: things fall down.

Of course, if you think about it for a moment, it is obvious
that before Newton developed his theory, people knew that
things fall down. Newton did not invent the idea of falling
to the ground. That vase would not have drifted upwards
before his time, nor would anyone have expected that it
should. Newton's contribution was a theory of gravity that
explained why and how things fall. This theory contributes
to people's abilities to act on the world, making bridges stand
up or sending satellites into space.

We might assume that scientific advance is the result of
greater precision in observation and measurement. Telescopes
and microscopes give us the capacity to see farther or in
greater detail. However, it is only theory that allows us to
explain the phenomena we observe. The great advances of
science are associated with new theoretical developments
that allow us to envision the universe and our place in it in
new ways.

Charles Darwin did not invent the idea of the evolution
of species. His own grandfather had worked on evolutionary
theories, along with many earlier thinkers. Darwin's great leap
was to develop a particular theoretical account that explained
how and why evolution occurred over time. His account
focused on the process of natural selection. The reproduc-
tion of new generations includes a certain amount of random
variation, meaning that occasional glitches in the process of
reproduction yield a mutation that has slightly different char-
acteristics. Darwin theorized that those characteristics that

allowed a species to thrive in its particular environment were most likely to be passed on, as the individuals so endowed were most likely to survive and reproduce.

Before Darwin, the French thinker Jean-Baptiste Lamarck developed a theoretical approach to evolution that was highly influential. Lamarck's approach suggested that characteristics acquired during the life of an individual could be passed on to their offspring, so that a deer that developed muscles through running a lot might pass that down to the next generation. Darwin and Lamarck, then, developed competing theoretical accounts that provided very different ways of understanding the process of evolution. These differences were fought out in sharp theoretical debates over a long period of time.

IN MY OPINION, MR. DARWIN, YOUR THEORY SUCKS

THE DIFFERENCE between Lamarck and Darwin was not simply a difference of opinion. One of the most difficult things to understand in the discussion of theoretical thinking is the relationship between theory, opinion, and fact. I will start with dictionary definitions for these terms, though I caution you from the outset that in social theory we often use terms in a technical sense that is not always captured in general-use dictionaries. Nevertheless, dictionary definitions are enormously useful, and one of the most important aspects of theoretical thinking is the careful use of words.

A theory, according to the New Oxford Dictionary of English, is "a supposition or a system of ideas intended to explain something, especially one based on general principles independent of the things to be explained ... " (Oxford 2001: 1922). In other words, a theory provides an explanation of a phenomenon that uses some sort of broader framework of understanding. This framework cannot simply offer a description of the phenomenon as an explanation. For example, it is

not a theory of evolution to say that over time the charac-
teristics of species change so they are more in tune with the
environment. The theoretical aspect is the explanation of how
this change occurs, referring to broader scientific frameworks
used for understanding life-forms.

An opinion, in contrast, is "a view or judgement formed
about something, not necessarily based on fact or knowl-
edge ..." (Oxford 2001: 1301). Opinions are deeply per-
sonal, depending on our tastes, feelings, and ideas about the
world. Opinions do not need to be based on any particular
claims to expertise. I can tell you that I think baseball is bor-
ing even if I hardly ever watch it (because it is so boring!!!).
There is nothing you can say that will convince me that I
should like baseball, even if you love it.

Finally, a fact is "a thing that is indisputably the case"
(Oxford 2001: 657). People claim that facts are beyond
dispute when they are based on empirical data, the informa-
tion gained through the use of our five senses. In principle,
as least, we can resolve a dispute about the facts by using
our sight, hearing, smell, taste, or touch. The term "fact"
involves a claim that the phenomenon in question exists out-
side of your head and is therefore accessible to your senses.
This does not mean, however, that we will easily agree on the
facts. In *theory*, facts are indisputable, though in *reality* we
argue about them all the time.

This all seems quite simple so far. The problem is that
facts, opinions, and theories get all mixed up in discus-
sions and debates. Indeed, in everyday discussions we often
fail to distinguish between differences in fact, opinion, or
theory. When the fans of two competing teams argue about
tomorrow's game, there is a fairly good chance that this will
include disputes over facts, opinions, and theories. The score
the last time the two teams met is a fact, though we might
remember it differently. Your claim that our star player is an
overpaid bum is an opinion. The statement that my team has
the best defense might involve elements of theory, if I relate it
to a broader analysis of effective strategy for defensive play.
In the more formal setting of academic disciplines, we are

Thinking Point: Theory and Persuasion

The ability to distinguish facts from opinions and theories is important in engaging with persuasion. Persuasion abounds in our contemporary society. Advertisements, for example, use catchy images and emotional associations to try to convince us that a particular product will make us thinner, stronger, smarter, faster, hipper, and way sexier. Politicians in debates, speeches, and press conferences try to persuade us that a vote for them is the only reasonable way to get a better future for all of us.

One of the best ways to handle persuasion is to take apart the message you are receiving by distinguishing between facts, opinions, and theories. The same political viewpoint, for example, might be expressed as a theory, an opinion, or a series of facts. The claim of Politician A, for example, that lower taxes will create prosperity for all might be an opinion, a view that is strongly held but not necessarily backed up by any evidence. If challenged, Politician A might defend that opinion using emotional appeals, by contrasting images of government waste with those of prudent, self-reliant families living within their means with balanced budgets. The wary voter might wait for a long time for a single real fact or a genuinely powerful theory.

Politician B might make exactly the same point, but argue in terms of a theory that lower spending increases consumer spending and therefore promotes economic growth, backing this up by specific factual evidence that this really is the case. Now we have something we can debate. Politician C, who argues that democratic access to education, health care, and social programs requires higher levels of taxation can challenge either the basic theory of Politician B or dispute the facts. In contrast, the only way to argue with Politician A is to sling back a different set of images or to make it personal: "You, sir, are an idiot."

Training in the fundamentals of social theory provides us with crucial tools for engaging with the rivers of persuasion that flow over us every day. Even the simplest distinction between fact, opinion, and theory goes a long way towards clarifying the grounds of specific claims. Further, it can help make you better at persuasion yourself. An academic essay is one formalized approach to persuasion, in which the writer develops a central theoretical argument and backs it up by marshaling effective evidence following specific rules of logic. Memos in offices and job application letters are also exercises in persuasion. You are more likely to impress with solid facts and effective use of theories than by the assertion of opinions, however good the rhetoric: "I am the person for the job!"

supposed to be quite clear about the relationship between theory, fact, and opinion. This can, however, be quite difficult, particularly given that opinion influences our preference for certain theories. Each theory is founded on key premises, cornerstone assumptions about the way things work. These assumptions are inseparable from beliefs about the way things should be. There is, therefore, a political dimension to theoretical work, as theories frame our vision of the world as it was, is, and might be.

For example, when Charles Darwin was a student in the 1820s, evolutionary theory in Britain was largely the domain of political and social radicals. It challenged the idea of a god-given natural order in which everything had its place. Thus, it was futile and destructive for the wretched of the earth to challenge their place in the world. The proponents of evolutionary theory challenged these ideas of a fixed and god-given natural and social order.

Darwin was not a radical in this political sense. Indeed, Adrian Desmond and James Moore (1991: xviii) argue he sat on his evolutionary theories for a long time before publishing them as he was afraid of their radical implications at a time of social upheaval in Britain. Stephen J. Gould (1977) points out that Darwin delayed publishing his theories for over 20 years and even then tried to downplay the philosophical implications of his scientific analysis.

The debate between Lamarckian and Darwinian ideas of evolution also had political dimensions. Lamarck was a French scientist, associated in the eyes of British conservatives with the French Revolution and the overthrow of that country's old order. Further, Lamarck's theory of evolution suggested that progress rather than order was the central theme of nature, as living things could develop new capacities in their lifetime and pass them on to offspring. If my activities or diet make me stronger or taller than my parents, then it is possible that these characteristics might be passed on to my children.

In contrast, Darwin argued that it was only inherited characteristics, and not those developed through activities over

a lifetime, that mattered in the process of evolution. A particular moth might be more likely to survive and reproduce in a smoggy urban setting than others of the same species as the result of an accident in the act of reproduction that happened to make it a bit darker than normal. The progress made by individuals over their life span had no impact on the evolutionary path of the species; what mattered were only accidents of reproduction that have nothing to do with any desire for improvement. Darwin developed this theory of evolution in counter-position to Lamarck and his radical followers (Desmond and Moore 1991: 315). Indeed, his vision of the natural world was deeply influenced by his reading of the conservative theorist Malthus, who argued that humans are in a struggle for existence in the face of scarcity as population grows at a faster rate than resources (Gould 1977: 21-22).

The debate between Darwinian and Lamarckian theories of evolution had important political dimensions, but that does not mean it can be reduced to opinions. It would not be very convincing to claim that Darwin's theory sucks or to attack him personally. Theoretical debate, particularly in more formal situations such as academic discussion, is based on arguments that meet certain internal and external tests. Internally, the argument should be consistent and coherent, so that the various conclusions flow logically from the premises. Externally, the argument should fit the facts, so that it should accurately predict the way things actually unfold. If my theory of anti-gravity predicts that I will float towards the ceiling as soon as I unwrap my legs from the supports of the chair I am resting on, then it will not fit the facts when I let go. Of course, the facts themselves are often themselves debatable, given that there are many possibilities for errors of measurement or interpretation.

Gould (2000: 116) claims that Lamarck's model of evolution fits the facts in explaining cultural change in human societies better than Darwin's. He argues that social change has particular properties that make it a special case within the broader realm of change within nature. Specifically, we can develop new cultural capacities in our lifetime and pass

them on to the next generation. I grew up in a country where polio had been largely eliminated by vaccination, while my parents lived through polio epidemics that saw kids confined to their own backyards. The knowledge to prevent polio is a cultural legacy developed in one generation and passed down to the next. At the same time, it is not true that the physical characteristics that individuals develop during their lifetime can be passed on genetically. An individual who lifts weights to build muscle does not change her or his genetic code in such a way as to produce more muscular offspring. Lamarck thus seems to fit the facts in explaining cultural change, while Darwin fits the facts in explaining biological evolution.

One of the most important skills you can develop in a theory course is the ability to unpack arguments, distinguishing facts from opinions and theories. This analytical skill will enable you to be much more persuasive, improving your ability to convince people to do things your way at work, challenge an unfair division of chores at home, or to do well in your course assignments. Learning theories is a crucial way to improve your analytical abilities, just as lifting weights might increase your physical strength. For many people, lifting weights is a means to an end, a way to develop the strength that is required in other activities such as running, swimming, or football. Similarly, training with theories will develop your abilities at critical thinking and persuasion, even if you do not develop an abiding interest in theoretical debate in itself.

FIND YOUR VOICE, IN THEORY

PERHAPS THE loftiest goal of education is that all students should gain new capacities to express themselves through their learning. The Women's Studies Program at the University of Windsor expresses this in a wonderful slogan: "Find Your Voice." Sadly, many students lose their voices in the classroom. They may feel they have nothing

to say about the topic at hand, which usually seems to have little to do with their own lives or experiences. Further, they may feel judged in a setting where it seems that the teacher is always evaluating and categorizing students. They actually find it hard to speak aloud in that setting, feeling a strain the makes it hard to get words out.

Keath Fraser (2002) was forced to think about the issue of voice when he developed a physiological condition that made his vocal chords go into spasms, choking his ability to speak. The condition first showed up in the classroom, where he experienced " ... an unfathomable acceleration of pulse, and a heart that thrashed at my chest wall like a crazed crow, before the inevitable sound of someone deeply troubled, deeply *flawed*, emerged from my throat when I was asked to read aloud" (Fraser 2002: 11). He assumed that this voice disturbance in class was a sign of personal failure. Eventually, he found out that this condition was physiological and could be treated by injections.

The voice is a funny thing. It has a mental dimension as the expression of thoughts, while at the same time as it has a physical one, the action of forcing air through vocal chords formed into a particular shape. These two aspects of voice are totally interconnected. For example, a voice expert consulted by Fraser (2002: 33) noted a similarity in pattern between stuttering and his own condition, called spasmodic dysphonia. Both these conditions had physiological dimensions, yet they tended to be triggered by "authority figures, having to speak in public, or before a group." They were less likely to be triggered by "speaking to underlings and children, to people you know rather than strangers, singing."

Finding your voice is more difficult when you are speaking up to power than in a situation of equality or one where you have the power. The classroom is built around an unequal power structure, as I will discuss in the next chapter. It is therefore a particular challenge to find your voice in this setting. That is particularly true given that your own expertise, grounded in life experience, is seldom part of discussion in the classroom.

The loss of voice inside the classroom is particular severe for those whose experience is most distant from the perspective generally offered from the front of the room. Himani Bannerji (1995: 57) powerfully discusses the experience of being cast as an "outsider" in university classes:

> Often I was the only non-white student in these classes....
> They carried on discussions as though I was not there, or
> if I made a comment ... the flow would be interrupted.
> Then they would look at each other and teachers would
> wait in the distance for me to finish.

The development of insiders and outsiders in the classroom is usually not a conscious activity. Professors and teachers often make an effort to be scrupulously fair. Yet lurking beneath this fairness are unconscious assumptions about what is important and what we in the room all share in the way of experience.

Dionne Brand (2001: 24-25) argues that the everyday world of contemporary Black people in the Americas is haunted by the historical experience of being violently removed from their places of origin and forced into slavery in another ("new") world. She refers to this forced removal as the "Door of No Return," the experience of coerced displacement that eliminates any possible return.

> Black experience in any modern city or town in the
> Americas is a haunting. One enters a room and history
> follows; one enters a room and history precedes. History
> is already seated on the chair in the empty room when
> one arrives. Where one stands in society is always related
> to this historical experience.

Yet this sense of loss, of the violent expropriation of self and community, is seldom if ever made a central feature of the shared understandings in the classroom, for reasons that will be discussed in the next chapter. Similarly, the specific life experiences of women, working-class people, and lesbians,

gays, bisexuals, or transgendered people are only rarely addressed in this context.

In this book, I am arguing that learning theory should be about finding your voice, about expressing your self in theory. That means your opinions and experiences are necessary but not sufficient parts of this learning process. The challenge is to work your own thinking into an analytical perspective that provides you with a framework to engage with formal theories.

THEORY AND COMMON SENSE

THE ITALIAN theorist Antonio Gramsci (1971: 323) argues that "everyone is a philosopher, though in his own way and unconsciously ... " Our thoughts and actions are based on sets of assumptions about the way the world works. We act on the basis of expectations that we generate through theoretical work that is often unconscious, generalizing from past experiences to model new situations and develop appropriate responses.

Gramsci used the term "common sense" to describe everyday philosophizing as opposed to conscious theoretical thinking. Our common-sense assumptions tend to be an eclectic blend of personal tastes and opinions; wisdom received from family, friends, or other influential individuals; and knowledge obtained from schools, religious institutions, political leaders, media, and other social institutions. We tend not to worry too much if the various bits of common-sense knowledge we have built up are not processed to the extent that they fit together into a tidy package that is consistent and coherent in any rigorous sense.

Gramsci was a Marxist activist who saw theory as an important component of freedom struggles. The undigested common sense we pick up here and there in our lives most often confirms the sense that the current world order is the only possible kind of social arrangement. He felt it was

necessary therefore to break with this common sense to begin to work towards a different kind of society, and this requires serious theoretical work. For Gramsci, then, it was crucial that theoretical thinking not be confined to an elite, but rather that it be opened up to become everyone's domain. Everyone must be offered the opportunity to think critically about the world, even to the extent of reflecting critically on our own common-sense assumptions. Gramsci (1971: 323) argues that it is better to:

> ... work out consciously and critically one's own conception of the world and thus, in connection with the labours of one's own brain, choose one's sphere of activity, take an active part in the creation of the history of the world, be one's own guide ...

The aim of this book is to invite you to use theoretical thinking to be your own guide. This can help you develop your capacities to act in the world to achieve personal, economic, or political goals. Clear thinking is not an obscure academic exercise but a crucial skill that will make you more effective in the world.

MAKING THE FAMILIAR STRANGE

ONE OF the key requirements for clear theoretical thinking is that we become aware of the taken-for-granted common-sense assumptions that generally frame our vision of the world. The sense that we already know the essentials is one of the greatest obstacles to critical thinking. Indeed, Terry Eagleton (1990: 34) argues that children often make very good critical thinkers as their way of seeing the world is not yet framed by deeply integrated assumptions about the ways of the world.

> Children make the best theorists, since they have not yet been educated into accepting our routine social practice as "natural" and so insist on posing to those practices the most embarrassingly general and fundamental questions, regarding them with a wondering estrangement which we adults have long forgotten.

Unfortunately, we adults cannot simply take on a childlike innocence and walk around asking naive questions. Through our lives, we have integrated assumptions about the world so deeply into our selves that we cannot separate our own perspective from what is actually out there.

Effective theoretical work therefore requires a particular kind of self-reflection, in which we become more aware of the frameworks we use to make sense of the world. The German playwright Bertolt Brecht (1964: 144) thinks that one step in the development of this kind of awareness is to make the familiar strange: "Before familiarity can turn into awareness the familiar must be stripped of its inconspicuousness; we must give up assuming that the object in question needs no explanation."

A good theorist assumes every phenomenon needs explanation and rejects the idea that the workings of the world are self-evident. Even an everyday sunset can stimulate us to think about the ways in which we know reality. John Berger (1972: 7-9) writes: "Each evening we *see* the sun set. We *know* the earth is turning away from it. Yet the knowledge, the explanation, never quite fits the sight." The sun looks like it is moving, even if you have learned that the earth is actually rotating around it.

Defamiliarization, looking at things we already know as if for the first time, is an important feature of theoretical thinking. It is necessary for effective analysis to ask basic questions about an everyday reality we already think we know. Theoretical thinking requires that we relentlessly hunt for the actual causes of the phenomena we experience, even if we think we already know the answer.

POSING THE BIG QUESTIONS

FORTUNATELY, we do not have to start from scratch in the analysis of our social reality. There is a huge body of formal theoretical thinking that we can make use of as we seek to understand the workings of the world. In fact, it may seem that there is too much of it, thick volumes of material filled with heavyweight concepts and marked by endless disputes and debates.

It is not my aim here to provide a full map of the bodies of theoretical thinking that have developed in the humanities and social sciences over time. Rather, this book is designed to give you some tools to make sense of the these formal theories as you encounter them. The aim is to provide you with a method of engaging with formal theories, seeking bridges that connect them back to your own experience.

In this section, I will discuss the ways formal theories are based on a few founding assumptions, or central premises. The universe of formal theory is comprised of different schools of thought, each one sharing a set of common premises. These shared premises answer such fundamental questions as: Is this a just world? How did things get to be this way? What can we expect in the future? How do we know?

The most effective way to engage with formal theories is to develop an understanding of the key premises of each school. This allows you to trace back the logic that links the analysis of a particular issue, such as crime, to a core of assumptions about the way the world works. I will introduce this concept by looking at one crucial debate that has influenced theoretical analysis in the social sciences: social order versus conflict. I am not claiming that this debate is the single key to opening every lock down the corridors of theory. Rather, it is one debate that has the advantage of clearly polarized positions, a long history of disputation, and fairly obvious application to a variety of contemporary social and political issues.

Theories based on the social order model make certain assumptions about the way the world works and how things

change. The conflict model disputes pretty much every one of those assumptions. If you track down the central premises of a theory, it will provide with an interpretive edge as you try to make sense of the particular features and details. If you try to learn a theory as a set of facts it is much more difficult and less rewarding than if you seek to understand it in the light of its key founding assumptions.

SOCIAL ORDER: THE BATTLE AGAINST CHAOS

THE CENTRAL premise of the social order model is that society is the crucial regulator that keeps people from acting in their narrow self-interest without the slightest regard for others. Lurking just beneath surface of our socialized selves are brutal self-serving beasts that will seize whatever they desire to satisfy their wants and needs. Society restrains the beasts and thus makes order possible.

The social order model underlies the work of many theorists, including Thomas Hobbes, Auguste Comte, Emile Durkheim, Talcott Parsons, and W.W. Rostow. It is the cornerstone of the functionalist school of social thought, the dominant perspective in sociology and many of the social sciences until the 1960s. It is still highly influential in academic disciplines and in politics; you are likely to find echoes of some of the positions articulated by conservative politicians in contemporary debates as you examine this model.

The social order model presumes that a well-regulated society serves the interests of all by protecting us against the threat of savagery that lies within us and throughout humankind. William Golding's (1958) novel *The Lord of the Flies* provides an interesting illustration of this perspective. A group of children stranded on a desert island start their stay by trying to preserve civilization but end up going wild. Early on, they try to establish an orderly regime. In the words of Jack: "We've got to have rules and obey them. After all,

we're not savages. We're English; and the English are best at everything. So we've got to do the right things" (Golding 1958: 47). By the end, they have become a terrifying mob the author refers to as "the tribe." In one incident, they chase after Ralph, the deposed leader: "Ralph stumbled, feeling not pain but panic, and the tribe, screaming now like the Chief, began to advance.... Ralph turned and ran. A great noise as of sea-gulls rose behind him" (Golding 1958: 200-01). If you have ever heard a flock of screeching gulls, you can imagine the sounds Ralph heard as he fled from the mob.

We will come back to this novel below in Chapter 4, and there I will address the ethnocentrism connected to the images of British civilization pitted against brutal savagery. It is ethnocentric to assume your own culture is superior to others and therefore to judge others as lesser.

The Lord of the Flies serves as a vivid illustration of the idea that social order is a particular product of societal regulation that protects us from the descent into chaos and bloodshed. The social order model seeks to develop social theory as a tool to help us understand how order is possible in the face of the constant threat of degeneration into self-serving brutality. The second premise that follows from this core assumption is that a population with a strong set of shared norms and values is one of the most important elements in maintaining an orderly society. People who share a common set of norms and values require a minimum of external policing to keep them in line as they have internalized the habit of regulating themselves.

It might seem that these common values would be threatened by social stratification, the division of society into a hierarchy in which some people have much more power and access to resources than others. This can create unrest if people at the lower end of the scale feel unjustly exploited. However, advocates of the social order model argue that people will accept social hierarchy providing that they see the system is fair and feel that their own contribution to the work of society is properly recognized. Indeed, stratification can be the basis for an efficient division of labour and a source of

motivation for hard work as people seek advancement. This becomes particular important in large-scale, complex industrial societies where the division of labour is highly specialized, so that jobs are highly differentiated from one another.

It follows, then, that advocates of the social order model argue that the role of the state is to preserve social order within a particular territory by enforcing these norms, whether by punishing wrong-doers or by socializing the population so that they internalize society's values. In an industrial society, this pushes the state towards pluralism in the political process, meaning that competing interest groups (such as employers organizations, trade unions, farmer's groups, ethnic and cultural associations, women's organizations, etc.) are represented. Negotiation between interest groups tends to produce acceptable outcomes over time, providing that no one is unfairly excluded from the process.

This means that advocates of this social order model can and do advocate social change, if it is required to eliminate unjust practices that serve as obstacles to pluralist participation in the production of a societal consensus based on shared values. Indeed, it is the character of modern, industrial society that those who wish to preserve social order must at times call for social change to handle the economic, technological, and cultural innovation produced by this kind of society. A pluralist state is particularly important for helping society through this process of change in an orderly manner. The reconciliation of order and change is one of the marks of this social order model.

Finally, it follows from the core assumptions of the social order model that the spread of industrial society to the less developed areas of the world should be understood as a process of modernization that benefits everyone. The contemporary process of globalization, as understood by this model, is simply the latest stage in a long-term modernization process. The gap between richer and poorer nations is explained in this perspective in terms of success or failure at launching into the development of a thriving industrial society. Those

nations that succeed in the development of a modern industrial society thrive, while others fail to prosper.

CONFLICT: CHALLENGING INEQUITIES

THE CONFLICT model rejects the assumption that the preservation of social order serves us all by protecting against the threat of chaos. Instead, its basic premise is that our present society is organized around fundamental inequalities that can be overcome only by a substantial transformation of social relations. The core assumption of this model is that social inequality produces conflict that leads to change. The disadvantaged have their own interests that conflict with those who occupy the key power positions in society. As they begin to act on the basis of these interests, they have the capacity to challenge the existing social order and change the world. This happens, for example, when workers organize into unions; people of colour challenge racism; women build movements for reproductive freedom, equity at work, and against violence; or lesbians and gay men fight back against heterosexism.

The conflict model is the foundation for many strands of Marxist, feminist, post-modernist, anti-racist, and lesbian-gay liberationist theories. In this view, society does not civilize people through moral regulation but rather stymies the human development of the disadvantaged through oppression rooted in systemic inequalities. Disadvantaged people are denied the chance to meet their full human potential and are therefore stunted by the experience of exploitation and oppression. The conflict model does not simply express compassion for the disadvantaged as victims of the system, but views them as social actors with the potential to change the world.

In the conflict model, theory is a tool to help unleash human capacities by challenging the power structure that

keeps people down. George Orwell (1966: 8-9) offers a vision of this kind of liberation in his vivid description of revolutionary Barcelona in 1936:

> It was the first time I had ever been in a town where the working class was in the saddle.... Waiters and shop-walkers looked you in the eye and treated you as an equal. Servile and even ceremonial styles of speech had disappeared. Nobody said "Señor" or "Don" or even "Usted"; everyone called everyone else "Comrade" and "Thou," and said "Salud!" instead of "Buenos días." Tipping was forbidden by law.... There were no private motor cars, they had all been commandeered.... The revolutionary posters were everywhere, flaming from the walls in clean reds and blues.... In outward appearance it was a town in which the wealthy classes had ceased to exist.... Practically everyone wore rough working-class clothes, or blue overalls, or some variant of the militia uniform. All this was queer and moving. There was much of it I did not understand, in some ways I did not even like it, but I recognized it immediately as a state of affairs worth fighting for.

The transformation of power relations Orwell described was so thoroughgoing that it produced new ways of acting towards each other, including more direct eye contact and the elimination of the old deferential and formal ways of addressing those more powerful than yourself, like "sir" or "ma'am" or "Professor." These are signs of the development of new forms of consciousness and new ways of living as the disadvantaged stake their claims for a more just world.

The conflict model is therefore critical of the idea of shared norms and values based on inequality in the present society. Rather than a genuine consensus, these are seen as ideologies that support the ruling order and perpetuate the disadvantaged status of the subordinate groups. For example, the American dream of rising from rags to riches might disguise the reality that most people move very little from the social

position of their parents and most of the powerful started life in advantaged positions.

The state, in this conflict model, does not serve the interests of all by defending social order against chaos, but rather acts on behalf of the most powerful by protecting a particular inequitable order against the claims of the disadvantaged. The state might appear to be a neutral referee as contending interest groups stake their claims on a level playing field, but according to the conflict model the rules of the game favour the powerful every time. The representation of subordinate groups within the corridors of power might create the illusion of full participation, but generally does not result in a significant change in the condition of the bulk of the disadvantaged population.

Social inequality amounts to exploitation, according to the conflict model. Privileges and resources flow to those in positions of power, while the contribution of the disadvantaged is always undervalued. The powerful might try to present this as a legitimate system in which those who have the most abilities rise to the top and provide the leadership we all require, but from the perspective of the conflict model the resources and privileges of the powerful can only have one source, and that is the exploitation of the disadvantaged.

Inequality amounts to exploitation on a global scale, as well. The so-called Third World is not simply slower to take off into wonderful modernization, but has been intentionally underdeveloped by the actions of the dominant nations, both in the period of colonization and since national independence. The dominant nations and the transnational corporations associated with them maintain their power in the global system through economic, political, and military activities.

MAKING SENSE OF THEORIES

IN THE chapters that follow you will be asked to relate particular pieces of analysis back to the core

debate between the assumptions of the social order and conflict models: social order is precarious and needs to be protected through societal regulation versus inequality creates conflict that leads to change. In the end, it is much less important that you get the right answer about whether a particular statement fits with the conflict or social order model than that you develop a good basis for defending your position. The challenge is to find the ways the core premises of the theory are reflected in a particular position on an issue.

Indeed, there is a great deal of debate even among experts about which statements and approaches fit with each of these models. It is often a complex question requiring interpretation and debate. There are, for example, theories engaging in a deep critique of the existing social order that are generally associated with the conflict model, but that do not share its optimism about the possibility of social transformation. There are variants of feminist theory that criticize the male dominance present in the existing social order (conflict model), but at the same time believe it is possible to satisfy women's demands with incremental reforms inside the existing economic and social system rather than through dramatic social transformation (social order).

The aim of this book is to give you some experience at tying specific analytical statements back to the core premises that underlie them. At the end of every chapter there are sample arguments that you should identify as conflict or social order. Getting the answer right is much less important than figuring how the key assumptions of the model are reflected in the sample arguments. This should help as you begin to tackle the complex task of making sense of formal theories. At the same time, I hope to intrigue you by showing the kinds of insights theoretical thinking can offer into our everyday lives.

Exercises

1. In a small group, compare notes on your understanding and information sources about the legal status and effects of marijuana on human health. Discuss the extent to which you share the same sources and understandings within your group. Come up with an example of a common-sense assumption about marijuana. Are these assumptions undisputed?

2. Keep a record of your experience as you visit a place for the first time—a street you've never walked down or a corner of the library you have never gone to. How do you navigate these unfamiliar spaces? What words would you use to describe your attitude to this new place? Try to take the same attitude in a place you know very well. Document your experience.

3. Write a paper from your own experience that supports or challenges Terry Eagleton's argument that children make good theorists.

4. Find an article in a magazine and analyze it to code where the writer has used theory, fact, or opinion; for example, write an "F" wherever you see a fact expressed, an "O" for an opinion, a "T" for a theory. Then write a brief paper discussing the persuasiveness of the article in light of the balance of theory, fact, and opinion. Are the theories backed up by facts? Do the opinions align with the theories?

5. Find a paragraph in a daily newspaper that seems to fit with the social order or conflict model. Write a brief account of the reasons you believe the quote fits with that model.

6. Break into groups of about 10 people. Each group should draw a statement from a hat at the front of the room. The groups then split in two, with one half responding to the statement from a conflict model perspective and the other half from a social order position.

Potential statements:

· Spare the rod and spoil the child.
· The death penalty is a crucial component of law enforcement.
· There needs to be more sex education in our high schools.
· Too many young, single women are getting pregnant these days.
· Our society is a model of successful multiculturalism.
· If voting really changed things, it would not be legal.
· The free press belongs to those who own a media outlet.
· The problem is that young people won't even apply for these jobs; their expectations are too high.
· Women earn less than men, even where they are doing the same job.
· High tuition fees make university education less accessible.

2

You Are Here: Mapping
Social Relations

In MALLS, universities, and other confusing places there are often maps posted around to help you find your way. These maps sometimes include a very helpful spot marked "you are here." Of course, you knew where you could find yourself before you even looked at the map. The "you are here" dot is to help you locate yourself in an abstract representation of the space you are navigating. A map is a very good example of abstraction, in which the unnecessary details are filtered out so that the key elements of the system (roads, rivers, walkways) stand out.

Social theories map the spaces we navigate, though in a rather different fashion than mall directories. We must negotiate social relations just as we find our way around a mall, a school, a workplace, or a street. We must know when it is appropriate to make eye contact, pay money, clap our hands, follow orders, or sit in silence. Most of the time, we do all of this automatically without having to think about it. It is only in a new situation, whether visiting another culture or entering a new setting, that we become conscious of the need to negotiate the expectations of others.

The aim of social theory is to make the complex web of social relations we negotiate every day visible to us. This is necessary for two reasons. First, the familiarity of these relations means that we do not think about them. After many years of schooling, for example, it simply makes sense to raise your hand before you speak, while at the dinner table it might seem absurd to do so. Secondly, just as the deep foundation that allows a tall building to keep standing is not obvious from the outside, so many key aspects of society are

anchored in relations that are not immediately visible from the surface.

Social theories, then, offer some sort of map of social relations, but they seldom include a "you are here" spot. Indeed, it is often very hard to locate yourself at all in many social theories. They are taught as already completed systems that exist outside you in forbidding books, and they often operate at very high levels of abstraction, stripping away all the details and particularities that make a scene familiar and leaving only the key principles that are often unrecognizable from the perspective of participants.

This chapter is the "you are here" spot in this book. We are going to start in the classroom, which is likely the context in which you are reading this book. The classroom seems very obvious to those of us who have spent considerable portions of our lives in them. It seems to be a logical place in which to organize ourselves to learn. In this chapter, I will show how theoretical reflection allows us to see things in the classroom that were not immediately obvious to us and to ask how the organization of the educational system reflects the social relations of the broader society. We will start from the classroom as a physical space and work back to a broader view of the social relations of education.

The examination of the classroom through most of this chapter is from a critical perspective influenced by the conflict model. The aim is to challenge your assumptions about the classroom and raise questions about a setting you might already take for granted. The "you are here" point in theory is the place where you are most likely to assume you know what you are seeing because it is all so familiar.

The chapter ends with two sample arguments about education, one derived from the conflict model and the other from the social order model. You will have to identify which is which, using the discussion of the central premises of these models in the previous chapter. It might be fairly easy to identify which sample argument matches the social order or conflict model; it is more difficult to establish your basis for

saying so, tracing key components of the sample argument back to their central premises.

INVESTIGATING THE CLASSROOM

I FIND IT hard to sit still in most classrooms. The seats are usually hard and uncomfortable. The little writing tablet is often painfully awkward for those of us who are left-handed (unless I want to play the "Where's Waldo" game of hunting down one of the few left-handed places squirrelled away somewhere in the classroom). As well, I frankly have to admit that I find it pretty hard to sit still for the full length of most of the classes I teach. I guess that is why I am the teacher.

If I have trouble sitting still in a classroom, it should not surprise me that some of the students in the classes shift, squirm, talk, sleep, or even get up from time to time. But I do my best to silence restless students. A good classroom interaction requires that attention be concentrated on the teacher or whoever else is speaking. Indeed, one of my big frustrations is that students are particularly rude to other students who are speaking in the classroom, paying far less attention to them than they do to me.

So I do my job, which is to keep things under control. But there is a part of me that recognizes the contradiction here: I daily expect my students to do something I cannot, which is sit still and let someone natter on for a long time. Yes, I try to make my classes as engaging as possible, using humour where I can, an animated tone of voice to sound enthusiastic, and lots of discussion, including group work where students are supposed to talk to their neighbours rather than listen to me. But I still have the nagging suspicion that something is not right.

My own sore butt has got me thinking about whether the classroom is really a good setting for learning. I have spent a fair amount of time reflecting theoretically on the classroom,

asking questions about a place I would normally take for granted. I wrote a book about the social relations of the classroom and the character of the educational system in a period of social change (see Sears 2003). The more I know about the classroom, the more I think my aching butt is trying to tell me something: the classroom does not provide a great situation for learning.

The design of the classroom assumes that the best way to learn is to sit still and listen to an expert who is lecturing from the front of the room. In larger classrooms, it is actually difficult to see and hear your fellow students if they raise a question or make a point. Either they are in front of you and their back is to you as they speak, or they are behind you and your back is to them.

The problem is that sitting and listening is not necessarily a very good way to learn. Paolo Freire (1972: 58) describes standard learning in the school system as the "banking" model of education, in which students store up nuggets of wisdom passed on by their teachers. At the end of the course, students open the bottom of their piggy banks and hand back those coins in the form of correct answers on an exam.

This model assumes that the job of students is to collect knowledge and then use the amassed wealth to purchase a good grade. But when you think of the most important things you have learned in your life, they probably did not come simply through sitting passively, listening and storing up. There might have been a classroom-like component, but that was mixed with some sort of activity. My driving lessons, for example, included a classroom portion and a fair amount of practice driving. I doubt anyone would expect me to be able to drive a car successfully after the classroom sessions alone, even if I aced the exam.

The most important learning we do always has a practice component, some form of activity. You learn to drive by driving, cook by cooking, and write by writing. Further, most of these learning situations involve interaction with others. We are helped through the practice component of learning by coaches, parents, teachers, or peers. The interaction is an

important feature of the learning, not just a distraction from the sound of the teacher's voice.

Yet, as we progress through the education system, there seems to be more and more emphasis on sitting still and listening. This is partly because our attention span expands as we mature; no one would dare try a three-hour lecture with Grade Three students. We therefore tend to learn such sophisticated topics as social thought by listening, rather than through any activity in the world. As a result, most students know theory as a set of coins they accumulate in a bank and cash out at the end of term, with nothing left behind unless there was a bit of interest (and we all know how little interest is paid on savings accounts).

Real learning is not just acquisition, it is transformation; we are changed by it. Knowledge is not a thing we pick up, but a way of seeing the world and living our life. Learning to cook combines bodily skills (knowing by taste how much salt to add or by feel when cream is properly whipped) with mental ones (planning a meal so that everything is done at just the right time). As you learn more about cooking, food actually begins to taste different. That is part of the transformation. Your approach to eating becomes more analytical as you gain the capacity to figure out the combination of herbs and spices that makes up a particular flavour sensation. We change as we learn, often in ways we do not recognize.

The banking model of education focusses primarily on acquisition rather than transformation. Schooling does, nonetheless, change us. People with more experience of formal education (for example, university as opposed to Grade 10 students) tend to have acquired specific competencies that are very useful in the classroom. Those competencies—for example, being good at figuring out what the teacher really wants you to do on an assignment—are often more important to your grade than anything else. The overt purpose of our education (to learn particular subjects and skills) is often less important than the "hidden curriculum" we are exposed to as we work our way through the school system. Terry Wotherspoon (1998: 136) says that "student school

experience is shaped at least as much by everyday practices, unwritten rules and informal expectations as by the overt transmission of knowledge and skills."

David Lloyd and Paul Thomas (1998) argue that the physical design of the classroom we are now so used to was not dictated primarily by the requirements for teaching and learning particular skills or topics. It was developed in the mid-1800s by education reformers in Britain who were concerned primarily with the formation of the student as a particular kind of citizen rather than with the development of specific skills such as reading or writing.

Lloyd and Thomas (1998: 19-20) discuss the ways the relations of the classroom prepare students for their eventual place as citizens in society. In the classroom, a group of individual students become a very specific kind of community. This community depends on the common activity of focussing attention on the teacher and following her or his directions. The students gathered in a classroom before the teacher enters or are not a community but a set of individuals including some linked by ties of friendship or collegiality and others with few ties to anyone else in the room. The teacher summons the room to order as a community and regulates the social relations between the individuals gathered there.

The key relationship that defines this classroom community is hierarchical—not primarily horizontal (the relations between students, who are relatively equal in power) but vertical (relations between students and the teacher who is the power figure). The teacher is the expert and the adjudicator, operating from a supposed position of objectivity. The teacher sets the terms for participation and grants students a voice in exchange for their silence when they have not been recognized after raising their hands. This community is collectivized by shared attention to the teacher but individuated by the competitive grading system that means students pass or fail on their own.

The relationship of students to their teacher prepares them for their eventual position as citizens of the state. Citizenship is not primarily defined by horizontal relationships (with

other citizens) but vertical ones (with state authorities and institutions). The teacher is the embodiment of the idea of neutral authority or "blind justice" that the state claims to represent, through policing, the judiciary, and a whole set of regulatory activities that help shape citizens with a particular set of expectations and attitudes (see Sears 2003: 34).

As you look around the classroom, it is worth thinking about what the room itself is designed to teach you. It is easy to take the classroom for granted as a space for teaching and learning, as this kind of place is used in so many educational and training activities. But as we examine this space theoretically, we step back from the obvious and ask questions about how and why it got to be this way.

WHOSE KNOWLEDGE COUNTS?

THE CLASSROOM frames a particular approach to knowledge, based on the assumption that the expertise is at the front of the room and the learning coming forth from the teacher is equally relevant to all of us, regardless of our backgrounds or interests. The knowledge on offer through the educational system claims to be universal and all-embracing, but in reality it is necessarily partial and one-sided. For example, through the educational system in Canada and the United States we learn to see the world primarily through the eyes of Europeans and people of European ancestry. The peoples of Africa, Asia, the Americas, and Australia enter the picture most often when they are explored or conquered by European empires. They are presented as knowable only through European eyes. The cultural and scientific approaches that are taught in school can be considered eurocentric in that they treat the specific historical experiences of peoples of European ancestry as if they tell the whole story of all of humanity (see Gordon 1995).

This eurocentrism is so taken for granted that it is often not visible to those who practice it. It creates a deep-seated racism that often flies below the radar screen of people who are "white." Himani Bannerji (1995: 46) writes, "Racism is not simply a set of attitudes and practices that they level towards us, their socially constructed 'other', but it is the very principle of self-definition of European/Western societies." Every time we refer to the continent of North America, and call the northern part of that Canada, we are making certain assumptions about whose land this is and how it got to be this way. The violent subjugation of Aboriginal peoples and their claims to the land simply vanish in the everyday act of referring to the place in terms that are explicitly Europeanized. These kinds of assumptions are built into the subjects and disciplines we study in school.

People who are not of European ancestry often feel excluded by this way of knowing. Dionne Brand (1998: 176) describes her schooling in Trinidad around the time it became independent from Britain:

> We went to school to become people we were not, we went to school to become people we would not be ashamed of, we went to school to uplift the new Black nation, we went to school to become people who could be acceptable to the country we were seeking independence from. We went to school not to become ourselves but to get rid of ourselves.

People who are excluded from the ways of knowing on offer in the educational system are often left feeling that the logical conclusion of schooling is to get rid of themselves. Dorothy Smith (1990: 21) writes that the academic world is built around masculinized ways of thinking that mean that women can succeed only by losing their own identity: "The problem remains; we must suspend our sex and suspend our knowledge of who we are as well as who it is that is in fact speaking and of whom."

Smith (1990: 17) argues that the powerful institutions in our society divide knowledge into two sharply separated modes: "one located in the body and in the space it occupies and moves in, the other passing beyond it." There are ways of knowing that are directly connected with our bodily experience and others that are far from it. Our knowledge of cooking, driving, hitting a baseball, or stopping a baby from crying is deeply rooted in our bodies, so that we often do them without thinking and might have trouble describing in detail what we are actually doing. On the other hand, our knowledge of social theory tends to come from books and often has very little to do with our bodily experience. The dominant division of labour means that women tend to be more engaged in caregiving than men and therefore more inclined to ways of knowing grounded in the body; for example, women may understand instinctively how the healing touch of a mother can reduce the suffering of a traumatized child.

The educational system favours the more abstract and rationalized knowledge "passing beyond" the body that tends to be most tied to the specific experiences of men. Men tend to learn to suppress emotion and to organize their lives into separate compartments so that, for example, an illness at home does not interfere with their functioning in their jobs at the office or the factory. Women are just as capable of these things, but the dominant division of labour gives women more responsibility for caregiving that is not easily compartmentalized. A sick child or a confused, elderly parent do not fit in easily with the timetable requirements of paid employment in contemporary society.

Theoretical reflection on the classroom, then, highlights features that are not obvious in everyday experience. It has been mostly the preserve of highly educated, white, upper-class men. In my view, this should not lead us to shut down theoretical thinking because it is horribly contaminated by this legacy of the past, but to open it up. One way to achieve that is to help you develop the capacity for theoretical thinking, so you are not only learning theories but also how to

bring new insights to your own analysis of the world around them.

Another is to open up the idea of who is a theorist. For example, Robin D.G. Kelley (2002: 154) argues that the radical Black feminist movement has widened the conception of the source of theory: "It expanded the definition of who constitutes a theorist, the voice of authority speaking for black women, to include poets, blues singers, storytellers, painters, mothers, preachers and teachers." Many people have rich insights into the way our society works which are derived from their reflection on the world as they are engaged in their life activities rather than from theory classes in some institution of formal education.

ABSTRACTION: THE ZOOM LENS

IT IS AMAZING what happens when you begin to wonder about something you thought you already knew. The core of theoretical thinking is that it allows you to reframe your view of the world around you. It allows you to zoom in very close, as though looking through a microscope and seeing in detail the many kinds of activity that take place in a tiny drop of liquid that looked perfectly clear. It also provides you with the ability to pull way back, like the views of the planet Earth taken from satellites that allow you to see the North and South Poles at the same time.

Theoretical thinking operates as a conceptual rather than a physical zooms lens. Theories provide tools for reflecting both on the tiny processes of daily interaction that normally escape our notice and on the grand view of time and space that is well beyond our usual field of vision. I will use the term "abstraction" here to describe this zoom lens feature of theoretical thinking.

The classroom, for example, is something you already know very well. The preceding sections of this chapter tried to get you to look at the classroom from different perspectives

than you normally do. Most of us begin our reflections on the world with our own experiences and those of the people who are closest to us. We supplement this with views of the world that we get through books, the Internet, movies, newspapers, radio, or television.

As we experience a particular situation over time, we generally begin to take it for granted. We file it in the category "already know that" or more simply "well, duh." We trust the insights that come from our experiences and use these as foundations upon which to build ever more complex understandings of the world around us. Yet, serious theoretical thinking challenges us to assume that the world as presented to us in experience can be very misleading. Bertell Ollman (1993: 11) argues strongly that analysis needs to go beyond appearances.

> The problem here arises from the fact that reality is more than appearances, and that focussing exclusively on appearances, on the evidence that strikes us, immediately and directly, can be extremely misleading.

All of us face many situations in which we have no desire to probe beneath the surface and ask hard questions about the appearance of things. For example, in the novel *Three Junes* by Julia Glass, Fenno reflects on his brother Dennis's lack of interest in probing more deeply into certain incidents: "Sometimes I wonder at Dennis's acceptance of the surface, as if the way things appear is enough for him" (Glass 2003: 190). Yet Dennis does not accept this surface level in every area of life. He is a professional chef who is passionate about his vocation. "But I suppose that other, more virtuous mysteries consume him: how cheeses age, how meats roast, why yeast and eggs rise and collapse" (Glass 2003: 190).

Much of the time we are simply willing to accept surface appearances, but there are some things we want to probe into deeper, to get beyond the descriptive questions (when and where) and ask the more analytical ones (how and why). I don't really care about how my computer works, but I spend

a lot of time wondering about how humans learn. Others are fascinated by the intricacies of mathematical reasoning, the potential for artificial intelligence, or the development of innovative code.

Sometimes psychological reasons prevent us from opening a can of worms by asking the big questions. Other times, familiarity leads us to accept things that might seem startling or incongruent to a stranger. People with extensive experience as students and teachers in educational institutions know a great deal about the classroom and the way it operates. There is no great mystery about what goes on there. By my fourth year as a university student, I went into most classes expecting to be bored and was occasionally pleasantly surprised by a really interesting teacher who got me engaged with the material.

Imagine the questions a stranger who had never taken a university or college course might ask while observing a class in session. She might stop by certain classrooms and wonder why the person at the front was reading aloud in a monotonous voice when it was patently obvious that no one was listening. She would observe certain students who tried to act like courtroom reporters by transcribing every single valuable word, while others doodled, whispered to neighbours, slept, or stared off into space. A stranger would see things in this setting that people who occupy it everyday do not, just as a guest in a home might notice patterns that the inhabitants fail to identify.

One of the challenges of the humanities and social sciences is that they focus on the human condition and therefore ask penetrating questions about the familiar which can be accused of being rather obvious. For example, take the question "how do we know?" At first glance, it seems painfully obvious that we know something when we see it, or more precisely when we can put a name on it such as "cat" or "dog." We are generally satisfied if something we see fits into a category we already have in our heads or if we can figure out what it is by looking it up or asking someone. We tend not to ask complicated questions about the relationship

between the image we form in our brain and what is actually out there in the world. One of the aims of theoretical thinking is to help push beneath the surface, such as by examining settings that might be very familiar.

As discussed above, for example, the classroom can be understood as a social setting structured around particular forms of inequality through a specific historical process involving institutions such as the state. That is a macroscopic view, examining the broad processes with an emphasis on the interrelation between the different aspects of a necessarily complex reality. A microscopic view, on the other hand, highlights the ways that individuals negotiate the rules of a particular setting, establishing themselves in relation to others. Teachers and students work through the rules and conventions of the classroom to meet their own goals, in the process establishing a self for the setting. The self people construct is bound to vary considerably with the setting; a student might be quiet and meek in the classroom and yet a loud and bold leader for the football team.

The zoom lens of abstraction, then, allows analysis to move from the microscopic close examinations to macroscopic grand visions. Ollman (1993: 24) examines the concept of abstraction in detail. Abstraction describes the process of framing an issue, establishing boundaries that define a discrete phenomenon within an always interconnected reality. He (1993: 24) begins with the simple notion that all reflection on reality requires breaking it into manageable parts. This is something people engage in all the time, often unconsciously. At the most basic level, we do this with our eyes in the way we focus on certain things and their surroundings. We establish foreground and background and divide our surroundings into meaningful units. This varies according to the character of the situation and the personality of the individual. A serious bird-watcher will look around the woods very differently than a cross-country runner racing through them. It is quite remarkable to be in a forest filled with bird-watchers who crowd around to marvel at some little speck on a branch you can't even see, let alone distinguish from an everyday sparrow.

As we move into the realm of theoretical thinking, we become more conscious of the ways that abstraction is employed to frame our view of reality. It is important to understand the process by which certain things have been included in the frame while others have been excluded. Ollman (1993: 40) suggests there are three dimensions to the process of abstraction: extension, level of generality, and vantage point. Extension describes the specific limits in time and space that bound a particular abstraction. The level of generality of an abstraction can range from the most specific (emphasizing the features that set a particular phenomenon apart) to the most general (emphasizing those features shared with other entities). Finally, vantage point describes the perspective built into each abstraction which necessarily views reality from a particular location.

This will be clearer if we go back to the examination of the classroom. As an undergraduate student, the abstractions I used to reflect on the classroom tended to be (1) local, focussing on the programs and institutions I had studied in, and immediate to the period of my studies (extension = place and time); (2) very specific, focussing on the courses I had taken and the professors who had taught me (level of generality); and (3) from the perspective of a relatively unmotivated undergraduate (vantage point). In contrast, when I began to write a book about education, the abstractions I used were (1) broader in time and place (extension); (2) more general, emphasizing broad similarities between classroom processes (level of generality); and (3) from the perspective of a teacher with a particular set of politics (vantage point).

Everyone reading this book will have some insights into the classroom from their own experiences at some level. These insights necessarily involve abstractions. The challenge in theoretical thinking is to be much more conscious about these abstractions. Do they derive from and apply to a particular time and place (extension)? To what extent do they describe only personal experience as opposed to common elements of schooling in general (level of generality)? What location framed these abstractions (vantage point)?

Thinking Point: Framing Knowledge

There you are, sweaty and tired after a long hike up the side of a canyon, marvelling at the stunning view. Suddenly, a busload of tourists dressed for a walk down main street crowds around you, having driven up the heights that you scaled with your own two feet. The ultimate frustration is overhearing someone say, "It's as pretty as a postcard" or "This looks just like an ad."

The same beautiful view can summon up very different responses, depending on how the view is framed. This can be understood again in terms of (1) extension, (2) level of generality and (3) vantage point. In terms of extension (1), the long climb up to the peak means that the view you get at the top is framed in time and space by the experience of the climb, the long haul up that offered you many visual experiences along the way. It is not a one-off, sudden, dramatic experience, as it might be if you were on a bus that just turned off the highway and presented you with an instant grand view.

The level of generality (2) might at first seem to be comparable, no matter which means you used to get to the top. After all, you are seeing the same sights below from exactly the same height. However, if you climbed up under your own steam, you also have some sense of the valley below and can pick out specific landmarks that you earlier saw close up. The folks on the bus see the same pretty view, but they get only the big picture and are unable to conjure up the same details that you can. Even at the same height, they are viewing the valley from a higher level of abstraction than you in that they are grasping only the highest level of generality. You, on the other hand, combine the mountaintop view at a high level of generality with your previous detailed close-ups at a lower level.

Finally, we get to the issue of vantage point (3). Again, everyone is looking at the valley from the same physical place, but that is not the only consideration that frames your view of it. Your experience of the view might be inflected with a particular shot of moral superiority because you climbed the mountain on your own. You have earned the view with your own sweat. That moral sense might be tempered if you realized that the people on the bus were mobility impaired and that the climb you just did would be absolutely impossible in wheelchair, with a walker, or with arthritic joints. Your vantage point, then, depends not only on where you are looking from but also on your key assumptions about, for example, tourism and leisure activities.

The abstractions we use in social theory are similarly framed. Emile Durkheim (1966), for example, wrote the book *Suicide* in

1897. His aim was to develop a unique sociological understanding of suicide, distinct from the psychological. He did not investigate the personal experiential factors that might lead individuals to kills themselves, but rather the sociological factors that lead to very different suicide rates among diverse social groups. He found that Protestants had higher suicide rates than Catholics in certain European nations and that married people with children had lower suicide rates than single people or childless married couples. He concluded that higher suicide rates were connected to more individualistic lifestyles and less intensive social cohesion, a phenomenon that produced *anomie*, or normlessness.

The concept of anomie is framed in very specific ways in Durkheim's work. It is (1) located in time and space (extension), as it is not a universal human condition, but a phenomenon peculiar to industrialized societies that have emerged over the past 200 years. Earlier forms of social organization did not produce anomie in this sense, and it is at least hypothetically possible that a very different society in the future might not either.

Anomie is also (2) at quite a high level of generality. It is not a characteristic of individuals (this child is more anomic than that one) but of social groups in specific situations. It is, therefore, not necessarily obvious at the level of day-to-day experience. Protestants in Durkheim's time might not have felt more anomic than Catholics, nor appeared so in any obvious way to an immediate observer. It was only at the level of the statistical comparison of suicide rates that these differences were visible. This does not make it any less true or important, but it does mean that the phenomenon of anomie needs to be sought out and investigated in the right places.

Finally, anomie is framed by Durkheim's vantage point (3) on his world. He was worried about the upheaval that seemed to be characteristic of the emerging industrialized society of the 1800s. The arrival of industrial society in France, Durkheim's own country, had produced a succession of insurgent uprisings and revolutions. According to Durkheim, the great challenge for sociology as a discipline was to overcome this turmoil by helping to identify the kinds of shared values that might produce a more sustainable industrial society. Durkheim himself neither favoured further revolutionary change nor turning back the clock to the good old days. The old values that had sustained order in previous times (such as traditional religions) were outmoded, and social peace depended on the development of new values compatible with an industrial society. Every time we use the term anomie, it bears the weight of those founding assumptions.

The same room can look very different when it is framed by a different set of abstractions. Think for a moment about the obvious difference between a teacher's experience of a classroom and a student's. The view from the front of the room with everyone looking at you and waiting for you to make things happen is quite different than that of the students who expect someone else to take charge. To add an additional dimension, imagine how the experience of that room might be different if your gender, race/ethnicity, sexuality, or social class were different. For example, as a white male teacher I learned a great deal by reading Himani Bannerji's description of her experiences as a non-white woman teaching in the classroom:

> I am an exception in the universities, not the rule. As a body type I am meant for another kind of work—but nonetheless I am in the classroom. And what is more, I am an authority. I grade and therefore I am a gatekeeper of an institution which only marginally tolerates people like us in scarcity rather than plenty. What I speak, even when not addressing gender, race and class, does not easily produce suspension of disbelief. (Bannerji 1995: 61)

Any individual will find certain abstractions easy to digest and others hard to take. The "suspension of disbelief" generally happens when we trust the source and do not challenge its analysis. Someone who offers up abstractions that do not fit easily with the ones students have assimilated over time is unlikely to be received with the "suspension of disbelief" and more likely to be challenged. This is particularly true when they do not fit with the (white, male) model of authority that tends to apply in this society. Reading Bannerji's words made me reflect on how my perception of the classroom is framed by my experience as a white male instructor who gets the benefit of the doubt.

A good course in theoretical thinking will introduce you to some viewpoints that you agree with and others that you do not. Some things you read might clarify insights you have

had for a long time while others will seem totally impossible to understand. The person beside you might see them in exactly the opposite way. The aim of this discussion is not to persuade you to adopt a particular view of the classroom, but to remind you that you already have one and might benefit from becoming more conscious of it. The more you are aware of the abstractions that frame your own thinking, the more you will be able to handle the various theories that are used in the social sciences.

BIG QUESTIONS AND GREAT DEBATES

THIS CHAPTER uses the analysis of the classroom in formal educational settings to ground a discussion of the way key abstractions frame our theoretical understanding of a setting. The particular analysis of the classroom presented here is based on certain abstractions, assumptions about the way the educational system works and how it fits into the broader society. These assumptions are hotly debated in the realm of social theory.

The discussion of education thus far in this chapter is founded on the premises of a conflict theory that presumes that the current society is based on inequalities that create conflicts and can only be overcome through significant social change. The education system contributes to the perpetuation of this unjust social order by preparing people to accept their eventual place either as rulers or subordinates.

In the preceding paragraph, I modelled a way of approaching the analysis of a theoretical position, tracking down the fundamental premises upon which it is based and establishing how specific understandings flow from that foundation. Theoretical discussion of the education system is informed by assumptions about the way society works and how things change. In the rest of this chapter, you will do this kind of analysis on your own, tracing back specific statements about

the education system to core assumptions of the conflict or social order model.

There are two contrasting theoretical arguments on the education system below. As you read these, try to figure out which is more likely to be associated with the conflict model and which with social order. It is more important that you think of the reasons for associating the argument with that particular model than that you get the answer right. The crucial challenge is to trace the ways key propositions in the arguments below reflect the central premises of these models as discussed in Chapter 1 above. As you read, think about how each of these sample arguments is grounded in a set of assumptions about the way humans live and the preconditions for a good life.

Argument A: School as Preparation for Industrial Society

conflict

Schooling is the best way for people in industrial societies to socialize their children. It provides the young with the skills, values, and drives required to succeed in a complex and rapidly changing world. Mass public schooling developed only with the rise of modern industrial society during the 1800s. Since then, the basic pattern has been one of increased participation, so that more people receive more years of schooling in each successive generation.

The socialization of the young becomes more specialized in an industrial society, where individuals require a wide range of skills and aptitudes to negotiate the challenges of everyday life. Traditionally, kids learned by doing, working, and playing alongside their kin and other members of their communities. These traditional child-rearing methods were no longer adequate with the rise of an industrial society, when it became necessary to raise individuals who could read and write, add and subtract, vote, search for jobs, move away to seek work as necessary, be patriotic, and raise the next generation with very limited external support. People need a much higher level of preparation for life in a modern, industrial society than was required in simpler, traditional ones.

want social change through increased education

The increased participation in education addresses this issue. Further, the increased emphasis on schooling can be taken as the marker of a more democratic society in which positions of power are increasingly gained on the basis of achievement, the individual accomplishments that qualify someone for the job, as opposed to ascription, being born into it. Now you need to be properly qualified for a job, by education and experience, rather than simply inheriting it from a parent. Increased educational attainment is one measure of a more just society.

Argument B: School Creates Deference to Authority

social order

The major aim of the educational system is to raise young people so that they are deferential to authority. The most important thing the educational system teaches students is to sit still, raise their hands if they wish to speak, and to regulate their bodily functions to the whims of those at the front of the room who will decide whether or not it is the right time to go to the bathroom. Children are taught to attune their minds and bodies to the requirements of those in power, for example, by sitting still however boring the class may be and spewing back whatever nonsense is required to get a passing grade on an assignment. The structure of the education system itself teaches certain life lessons.

Mass public schooling developed as part of the social policy of the state, which attempted to damp down the unrest associated with the rise of capitalism. The modern factory, the office, and the nuclear family require particular forms of discipline that must be developed through special forms of teaching. Unlike agricultural work, for example, which is driven by natural factors (daybreak, sunset, rain) and the time required to get the job done, factory and office work require that everyone show up at the same time and work through their shifts. Schooling helps prepare people to show up on time and to work obediently under general supervision.

Unfortunately, it is simply not true that mass schooling is a sign that positions of power in our society are assigned on

the basis of achievement rather than ascription. The social position you are born into and the other characteristics ascribed at birth (sex and race) largely determine your life possibilities even in contemporary society. Access to education, for example, is still influenced by such factors as the wealth and educational attainment of your parents.

Activity 1: Gathering the Evidence

If you are fortunate enough to have taken a good writing course in university, the introduction to this activity might seem old hat. Many students, however, do not have that opportunity. I am going to take a bit of time to explain the rationale for this activity as well as the product you should come up with in the end.

Academic writing often seems like a mystery to students, an obscure form of expression shrouded in a mystical set of rules that you learn about only when you break them. Papers are returned with markings in secret code, alleging this or that transgression of the great laws of formatting, punctuation, or argumentation. Just when you think you have it all figured out in one course, you find the rules are all changed in the next one.

At its core, most academic writing is about making an argument, setting out a key position, and then backing it up with appropriate evidence. This is not always made obvious, and it can be difficult to figure out the core argument of some pieces you be reading. It is my impression that students often see their role in academic writing as that of a collector, pulling together a bunch of obscure facts or quotes and pasting them on the page without making any particular point with them. The idea that it is their job as writer to make sense of this material is never made clear. The safest strategy in the face of the red pen of the teacher is to hide behind a collection of quotes and facts coming from other authorities and to eliminate any sense of the writer. This is particularly true given that you are often discouraged from writing in the first person ("I" or "we") in academic writing.

The activities included at the end of Chapters 2 to 5 are designed to show some of the steps towards the production of a paper that makes a point. Of course, this is not a definitive guide to academic paper writing, but they will help you to prepare for this kind of writing.

The first activity is to gather the evidence and organize it in a way that will allow you to make a case. There is, indeed, a collecting aspect to writing; it is necessary but not sufficient to produce a good paper. This first activity will show that good reading is the basis of good writing.

Begin with four pieces of paper. On one page each, identify and list the key premises of the conflict and social order models as discussed in Chapter 1 above. Go through the discussion of the models and identify the central assumptions that lay the foundation for all that follows.

Next, list each of the major points used in the two sample arguments above, each on a separate sheet of paper. Try to distinguish the major points from the details used to develop or support them. You should end up with a list of no more than three or four major points.

Then pair the pages off, so that you match each argument with the appropriate model. Now the hard work begins. Beside the major points for each argument, list the premises from the model that are related to that position. For example, if there is a premise that assumes that people are naturally combative and a position that says that school trains people to live in peace with one another, identify the connection between the premise and the position. Write a brief statement that says how the position reflects the premise you have indicated.

That is the key background work for a paper. Effective writing begins with this kind of methodical reading in which you actively figure out the major points that are being made. The next step is to figure out a way of expressing the key distinguishing points between the two lists, each associated with one model. The process will be modelled in the next chapter.

Exercises

1. In a small group, come up with as many examples as you can of situations in which you were members of an audience over the last year. Discuss what makes a particular audience experience good or bad. How does the classroom compare with these other experiences? Why?

2. Keep a record of the skills that you use on a particular day. Rank those skills in terms of their importance in your life. Write a brief description of how you learned the three most important skills.

3. At the beginning of a class, make a sketch of the room you are in. The aim of this exercise is to map the flow of information in the room. If the class is small enough, try to indicate where each individual sits. If it is large, then represent a good number of them. Use arrows to show anything that is said, indicating who said it to whom. Hand it in with a discussion of what you have learned from this.

4. Work in a small group to develop a way of teaching your classmates something that you know well (it could be a sport, music, cooking, or whatever interests you). Be very conscious of the way that you would go about teaching and how or why you would evaluate their success. Test out the strategy on members of another group and then assess the effectiveness of your approach. What worked and what did not? Why?

5. Find another source that gives you a theoretical analysis of the way classroom education works. Write a critical analysis of this source to identify the ways it fits or does not fit with either the conflict or social order model.

3

*The Real World: Making
Sense of Perceptions*

Each social theory provides us with a vision of what is realistic in the context of the world we inhabit. This chapter explores the idea of reality and its place in social theory. The prime focus is on phenomenology, a school of theory that has worked a great deal on the idea of reality.

Reality seems like something outside us, the external world independent of our thoughts. Yet phenomenology reminds us that we produce the outside world by filtering and organizing the things we see, hear, smell, taste, and feel. We sort things into categories all the time, without thinking about it. We see an animal and make it a cat or a dog, determine if it is friendly or fierce, beautiful or ugly, smart or dumb, all before we have really thought about it.

A large chunk of this chapter is designed to problematize the whole idea of reality, to make it a challenge we need to think about rather than something obvious. The final sections deal with the idea of realism in the context of society. What is realistic in any given situation is a matter of debate. Different theoretical perspectives provide a very different read on what is or is not realistic, for example, in contemporary debates about globalization.

THE REAL WORLD AND
THE IVORY TOWER

Students often worry about the relationship between the things they learn in their courses and the real world out there. Unless you go on to graduate school, it

is quite unlikely that you will ever again hear the names of many of the writers you study in a theory class. So why do you need to know them now?

In this chapter, I will try to convince you that theoretical reflection can help prepare you for the real world by encouraging you to ask what makes things "real." At first glance this is, of course, dead obvious. You know something is real when you can touch it, see it, smell it, taste it, or hear it. In other words, we associate reality with empirical data gathered through our five senses. However, the theoretical perspective of phenomenology, which I will introduce below, raises important questions about our relationship with the apparently obvious reality around us. Throughout this chapter, I want you to think about the ways phenomenology raises questions about your everyday perceptions.

At any given moment, our senses are bombarded by an overwhelming amount of information. This is obvious on the crowded streets of a city you are not familiar with—the pounding traffic sounds, the push and shove of people on the crowded sidewalk, the smells of exhaust or exotic spices or fast food, the sight of towering buildings or temporary-looking shacks, and the movement everywhere. Even in a quiet library when you are trying to study, the whisper of someone a few tables over, the jingling of change in a pocket, or the flicker of a failing fluorescent light can be distracting.

We are not simply taking in all this information and storing it, like a gigantic video camera. There is a massive process of selection and organization that goes on in our bodies and minds. John Berger (1972: 8-9) describes this process: "We only see what we look at. To look is an act of choice.... Our vision is continually active, continually moving, continually holding things in a circle around itself, constituting what is present to us as we are." Indeed, all of our senses are active, not passive, working on the world out there and not simply taking it in.

The process does not end there, for an important organizing process occurs as our senses take the information in. We assimilate new experiences by connecting them to previous

ones, classifying them as similar or dissimilar (the frog's leg does or does not taste like chicken). The notion of reality quickly becomes more complicated as we reflect on it theoretically.

THE REAL AND THE IMAGINARY

CANADIAN WRITER Margaret Atwood (2000) argues that her own sense of reality was shaped in part by her childhood experience of spending time remote from her extended family at the research station in northern Québec where her father worked. "Because none of my relatives were people I could actually see, my own grandmothers were no more and no less mythological then Little Red Riding Hood's grandmother ... " (Atwood 2000: 7). She grew up as an avid reader who found little to distinguish between the fictional worlds of the books she read and the distant worlds inhabited by her relatives. In these circumstances, she developed a mind set that equipped her well to be a writer: "the inability to distinguish between the real and the imagined, or rather the attitude that what we consider real is also imagined" (Atwood 2000: 7).

"What we consider real is also imagined." Margaret Atwood has given us a rather elegant statement of the more complex version of reality we are exploring here. The real world and the world of the imagination are not separate and opposed, but rather are deeply interconnected. This is not to deny that there is a real world out there, though that is certainly a topic of considerable debate among social theorists. The real world might be out there, but you and I have access to it only through the actions of our own minds and bodies. We need to touch it, taste it, see it, smell it, or hear it. These sensations are organized in our thoughts according to classification schemes of which we are seldom directly aware.

If we did not organize our thoughts, we would be overwhelmed by sensations. We can only cope with the

tremendous overload of sense data we receive every second by filtering out most of it and focussing selectively. We are not even aware of this filtering process most of the time; we simply accept that some noise is background (the tapping foot of the person sitting beside you) and other noise is foreground (the sweet tone of your professor's voice).

The presence of this filtering process becomes most obvious when we contrast it with the experience of people living with autism, who often have great difficulty organizing sense data. Dr. Temple Grandin is a person living with autism who used her powerful visual imagination to become a professor and designer despite her difficulties with written communication and in certain interpersonal settings. In her book, she describes the ways that ordinary sense experiences overwhelmed her. As a child, she could not bear to be touched: "It was like a great, all-engulfing tidal wave of stimulation, and I reacted like a wild animal. Being touched triggered flight; it flipped my circuit breaker" (Grandin 1995: 62).

She also reports great difficulty handling sounds in the environment. Loud noises cause pain, "like a dentist's drill hitting a nerve" (Grandin 1995: 67). Minor background noises distract her: "I still have problems with losing my train of thought when distracting noises occur. If a pager goes off when I am giving a lecture, it fully captures my attention and I completely forget what I was talking about" (Grandin 1995: 67). She describes the overall effect: "My ears are like microphones picking up all sounds with equal intensity" (Grandin 1995: 68).

Autism, then, can have the effect of flattening the sensory landscape, so that every sensation demands equal attention. In contrast, people who are not autistic are generally able to sort highlights from background. Consciousness is the process through which we organize the tidal wave of sensations into meaningful units of reality. Our environment would be an incomprehensible array of sensations were it not for our facility for consciousness, which allows us to actively make sense of the world.

It is through consciousness that we organize the sensations that bombard us. It is only through consciousness, for ex-

ample, that a particular set of sensations (the barking sound, the feel of the tongue, the smell of wet fur, the look of four legs, and a particular profile) becomes a dog. As the influential phenomenologist Alfred Schutz (1978: 266) writes:

> We do not experience the world as a sum of sense data, nor as an aggregate of individual things isolated from and standing in no relation to one another. We do not see coloured spots and contours, but rather mountains, trees, animals, in particular birds, fish, dogs, etc.

Phenomenology is the theoretical school that focusses on the examination of consciousness. Jeffrey Alexander (1987: 241) describes its central premise: " … reality is structured by perception. Even the things whose objectivity we normally take for granted are 'there' for us only because we make them, or take them to be so." Phenomenology studies the ways our own consciousness structures our understanding of reality in ways we do not often recognize.

In our everyday lives, we rely on the core assumption that the world around us is made up of objects that exist outside of our minds and are independent of us. An object is defined in the New Oxford Dictionary as "a material thing that can be seen and touched" (Oxford 2001: 1277). People can only see or touch things that are outside their own mind. The dictionary adds a technical definition from the field of philosophy, "a thing external to the thinking mind or subject" (Oxford 2001: 1277).

As I wrote the previous paragraph I tasted tea, heard a cat meow, felt the breeze from my fan, saw a dictionary in front of me, and smelled the fresh-cut grass in my neighbour's yard. In my experience, each of these sensations seems to emanate from the objects themselves so that my senses simply capture a bit of the reality around me. Tea has a particular flavour, for example, and my taste buds did their job by sensing that and sending a message to my brain. It is my assumption that the taste of tea is a property of that object, end of story.

Phenomenology challenges us not to leave the story there. The sensations we think of as properties of the objects around us are in fact products of our own consciousness. This does not require that we deny the existence of the external world, but rather that we understand that our access to this world is always mediated by our consciousness. The goal of phenomenology is to make us aware of our own role in the making of the real world that seems to exist beyond us.

Consciousness works primarily through a process of typification, sorting sensations into a series of types or categories based on similarity to previous experiences (Schutz 1978: 269). This requires that our recollections of our own past are organized in an orderly fashion, as in a good filing system. New experiences are assimilated into existing categories in this system, just as any new item in a filing system gets put somewhere. If you had to open a new file for every single item that came along, the system would be useless. Similarly, if you crammed every item into one folder, you would have gained no organizational edge. The aim in filing is to develop a set of categories that enables you to identify the similarities that will lead to grouping items while at the same time noting the key differences that require separate headings. We similarly organize our sensations, though often without reflecting on the process.

Schutz (1967: 81) describes this process: "With every moment of conscious life a new item is filed away in this vast storehouse." Confronting a new situation, people retrieve a similar situation as a reference point. You wait for a call from a potential employer, and your consciousness reminds you of how it felt to sit by the phone hoping for that much-wanted call for a follow-up after a great first date. You access a whole set of feelings, behaviours, and information.

We organize our experiences around key principles that inform the whole system of categorization. Most importantly, we use concepts of time and space to organize our experiences into meaningful categories. Peter Berger and Thomas Luckmann (1967: 22) argue that we understand the world relative to the "here" of our bodies and the "now" of our

present: "This means that I experience everyday life in terms of differing degrees of closeness and remoteness, both spatially and temporally." We sort objects around us into near and far, and therefore are not shocked that people who are farther away look smaller. Of course, the first time you go up a really tall building and see people scurrying at an ant-like scale below, it can be pretty startling. Your senses quickly adapt, though, and you take for granted that those tiny specks scurrying below are actually people the same size you are.

Thus far, I have described consciousness in a very individualistic way, emphasizing the way each of us develops the capacity to organize our experiences in a highly orderly fashion. Yet at the most obvious level, these categorization schemes are shared. My category "dog" and yours are probably quite similar, though we might get a very different image in our heads when the word is mentioned. Shown a picture of an animal, we are likely to agree about whether it is a dog, cat, or mouse.

Consciousness is social, then, with a serious shared element to our categorization schemes even though we have no direct access to the thoughts in each other's heads. This means that we must assume, but can never know, that others share the same kind of consciousness that we have. When we interact, we take for granted that the other person "is conscious, and his stream of consciousness is temporal in character, exhibiting the same basic form as mine" (Schutz 1967: 98). We can only understand others through intersubjectivity, interacting with the other on the assumption that she or he sees the world pretty much as we do.

Pet owners display intersubjectivity when they assume that their dog possesses a consciousness like their own: "Poor Fluffy. She misses me so much because I've been away all day doing my stupid job. Come here girl, I'll make it better." Dogs are social animals, and they probably have missed you, but if they could talk, they would probably not express the thoughts you impute to them.

The tricky thing about consciousness is that it makes things seem real and outside of the head of the individual.

The role of our own perceptions is relatively invisible to us. The categories do seem to exist out there, and we assume that what we are getting is little units of reality captured as if on video tape and stored in our memories. In the language of phenomenology, this stance of accepting the reality of the external world is referred to as the "natural attitude." Schutz (1978: 257) explains: "in this attitude the existence of the life-world and the typicality of its contents are accepted as unquestionably given until further notice."

In the natural attitude, then, the activities of our own consciousness in organizing the world around us are invisible to us because we assume that the characteristics we assign to objects are inherent properties of the thing itself. We assume, for example, that chocolate tastes good and spinach does not. Nothing simply tastes good, however, without an interpretive process through which we organize our sensations.

I used to hate the taste of beer, and my social life was a disaster. One summer, I taught myself to tolerate it so I could go out drinking and share pitchers of draft with friends. At first, I had to treat beer like a medicine, forcing it down with a spoonful of potato chips for a more pleasurable taste sensation. I grew to love the taste of beer and developed quite a picky palate with a preference for the more flavourful brews. I even grew to like room-temperature draft beers served in pubs in England that made some of my fellow North Americans moan. A flavour that had once been very off-putting has become so desirable that I seek out stronger forms of it.

Beer, then, does not inherently taste good or bad. I taught myself to like beer through a process that included my own sensory experiences and interchange with others. People can learn to like flavours that at first seem repulsive. If beer tastes good to me, that is because I have organized the system in my head so that beer gets filed under "yummy." But when I crack open a cold beer on a hot summer day after a long hike, it hits the spot, without any interpretive effort on my part. We attribute to the objects around us characteristics that we assign them through our consciousness.

This makes consciousness very difficult to study. Consciousness disguises itself in the act of making the world seem real. The first step in any phenomenological study must be to render consciousness visible. This is done through bracketing, which requires that we direct our attention away from the things on the outside and focus on our own process of making sense by organizing and classifying. Schutz (1967: 37) writes that phenomenology involves a commitment to "turn away from the world of objects ... and direct my gaze at my inner stream of consciousness." Phenomenology insists that we attend to our own role in structuring reality.

Pain, for example, seems like a simple objective phenomenon. We all take for granted that some things hurt and others do not, and we know pain when we feel it. But the theory of phenomenology urges us to go further. Serious athletes derive great pleasure out of doing things that cause pain. My bother runs marathons, and I do not understand why he chooses to suffer. A friend told me about an aunt of hers who could take anything out of the hot oven with her bare hands, never using pot holders. I love listening to certain kinds of music that actually cause pain to some of my friends, who insist I turn it off immediately. I know people with stacks of piercings in all kinds of places that I don't want anybody poking through with a needle! I look at them and think, "Ouch!!"

There is no clear line between pain and pleasure. It is only through our consciousness that we organize sensations into these categories. Bracketing requires that we open up the question of how and why we categorize some things in a particular way while others view them differently. Next time something smells good or bad, stop to ask yourself why you think that. The smell of charred wood can bring to mind the romance of a campfire or the horrors of a burned-down family home. This is not a property of the thing itself.

Bracketing is a real challenge; it means going against the assumptions that serve us well and make sense of our everyday life. Berger and Luckmann (1967: 23) describe this in powerful terms:

> The reality of everyday life is taken for granted as real-
> ity.... I *know* that it is real. While I am capable of engag-
> ing in doubt about its reality, I am obliged to suspend such
> doubt as I routinely exist in everyday life. This suspension
> of doubt is so firm that to abandon it ... I have to make
> an extreme transition.

Phenomenology invites us to make this extreme transition. It is not surprising that many students reject this invitation, assuming it is a typical academic waste of time to ask prob-ing questions about the obvious. Yet, it is possible to gain powerful insights by bracketing, casting doubt on the obvi-ous. There is a great deal to learn about the simplest of our everyday interactions. For example, why does a particular piece of music sound great to you and horrible to another? The phenomenological approach leads you to attend to the ways your ear has been trained to listen to music in very spe-cific ways to appreciate certain sounds and dislike others.

Ethnomethodology is a wing of phenomenological theory that focusses on the process through which social norms are integrated into consciousness. This is a more complicated process than it first appears to be. People generally assume that they are rule-abiding, even if, in practice, that requires a very broad interpretation of the rule. We need to be more aware of the ways we stretch the rules to cover particular situations. For example, many of us subscribe to the rule that we should tell the truth. Yet, even people who would see themselves as honest will not always tell the truth when they are asked, "Does this shirt look good on me?" We do not want to be hurtful and therefore do not tell the truth under particular situations. Our consciousness allows us to recon-cile our self-image as rule-abiding with everyday practices of transgression that redefine the rules.

Harold Garfinkel (1967), one of the developers of ethno-methodology, has developed a practical approach to brack-eting that he calls "breeching experiments." These involve practical exercises that disrupt people's everyday lives and make them more aware of the taken-for-granted assumptions

Thinking Point: Bracketing and Breeching Experiments

Bracketing is the commitment to looking at the world through new eyes, putting aside the interpretive process we normally use to frame reality in our consciousness. If someone waves a hand at me, I should put aside the assumption that I know what they are doing and ask instead what they mean. This is a philosophical approach to the world, one that is admittedly rather difficult to put it into practice as we are so used to the world as framed by consciousness that it is almost impossible to know where the reality outside us ends and our own interpretive process begins.

The practice of meditation gives a bit of insight into bracketing. In meditation, you attempt to set aside all the content of your thoughts to reflect on thought itself. For example, you can concentrate on your own relaxed breathing or a repeated chant or the flickering of a candle with such intensity that your mind is emptied of its everyday clutter. You escape from thinking about term papers, bills, social activities for the coming weekend, or your job. Instead, you float freely in a realm of pure mind, cleansed of all particular thoughts.

There are certain parallels between the opening up of the mind through meditation and the process of bracketing as discussed in phenomenology. We are always conscious of something, and through bracketing we attempt to set aside the thing we are conscious of to explore consciousness itself. There is a self-reflexive character to this activity, much as there is to meditation.

Breeching experiments as proposed by ethnomethodologists provide a different approach to exposing consciousness, disrupting settings to expose the ways we act on the basis of taken-for-granted assumptions about the rules that govern a given situation. It is as simple as picking up the ringing telephone and saying nothing, or moving just a bit farther away from someone than you normally would in a conversation. You begin to detect a whole set of precise rules that govern personal space, conversation, and, in fact, all of our interpersonal activities.

Finally, you will detect the complex process through which we stretch the rules to cover our own behaviour. Watch, for example, as someone who thinks of themselves as polite reacts to a homeless person on the street who asks them for money, or a light, or even the time. Suddenly, all the basic rules of polite behaviour are off. There is no eye contact, the homeless person is aggressively ignored whatever they are saying. Somehow, there is an interpretation of the politeness rule, perhaps an exemption on the basis that the homeless person poses a threat or is categorized as drunk. Yet, there is probably no evidence of a threat or drunkenness.

Breeching experiments can be a really interesting way to figure out how we apply rules without thinking in social situations. At some level, hidden camera television shows are a kind of breeching experiment, often conducted just for laughs. Television shows are not bound by the same ethical considerations that shape academic research. If you are interested in running off to begin breeching experiments, remember that the first consideration must be that you do no harm to others, whether physical, emotional, or social.

that shape their existence. These "breeching experiments" require that participants perform minor disruptions that make the implicit assumptions in a situation clear. For example, in everyday conversation we do not expect a real response to the question "How are you?" Try answering with a list of ailments and complaints—"my stomach is a bit off, I've been depressed since September, and my hæmorrhoids are acting up"—and watch the other person squirm.

It is quite easy through disruption to uncover the hidden assumptions that govern personal space, conversation, eye contact with strangers, and overhearing. Our consciousness allows us to take for granted a whole series of behaviours and actions that might otherwise appear quite outlandish. For example, public cellphone use on a bus or a train often depends on the shared understanding that no one else is listening, even if those around the speaker have no choice but to hear every word. Breeching experiments require that people speak up and join in the conversation, challenging the tacit agreement that everyone pretend this public activity is going on in private.

PHENOMENOLOGY AND INEQUALITY

THE PHENOMENOLOGICAL approach to the social construction of our everyday lives can be very helpful in understanding how practices of oppression are

highly visible to those who face discrimination and yet are not perceived by those who are exhibiting prejudice. The key axes of consciousness often include categories of race, sexuality, gender, and social class that are simply taken for granted.

The comedy show "Saturday Night Live" had a long-running skit that explored the phenomenology of gender. The character named "Pat" was hard to place as either a man or a woman. The other characters spent their time during these skits trying to label Pat male or female. The instant categorization of people as male or female, with a whole set of expectations attached to the label, is an important part of our cultural repertoire. People are sometimes quite upset when they find out this classification is wrong. In the novel *Dead Souls* by Ian Rankin (1999: 475-76) Nicky is a transgendered person, biologically a man who appears as a woman. Nicky's sister describes what happened during a party on a boat, when Nicky picked up a guy named Damon.

> Nicky had his head on Damon's shoulder, and just for a moment our eyes met ... and he looked so happy.
>
> But a drunk named Alfie interfered.
>
> Alfie was as drunk as I've ever seen him. For a joke, he leaned over and snatched Nicky's wig.... And Damon just stood there, like he was thunderstruck. He looked ... it seemed rather hilarious at the time. His face was a picture. Then he ran for the stairs.
>
> Nicky ran after him, pursued by his sister.
>
> By time I came up on deck, this Damon person had Nicky down on the ground. He was strangling the life out of him, and at the same time thumping his head against the deck...

Damon, then, had a great deal invested in the categorization of Nicky as a woman rather than a man. Once the wig was snatched and Nicky appeared as a man, Damon responded violently. Transgendered people frequently face violence and harsh discrimination in contemporary Western society where

those who upset people's gender categorization may be punished with brutality.

Phenomenological theory has tended to spend insufficient time examining the ways that consciousness is gendered, although the theory offers potentially valuable tools for understanding the process through which gendered expectations are imposed in our everyday lives (see Levesque-Lopman 1988). Gender is one of the first things we tend to see in other human beings, and in those cases where it is not obvious, such as a baby, parents will often go to great lengths with blue and pink outfits to make sure it is visible.

The visible signs associated with "race" (skin colour, eye shape, hair texture) also tend to register very quickly in the consciousness of contemporary North Americans. Even those "white" people who are not overtly racist quickly categorize others according to racialized criteria. Frantz Fanon (1967) was a person of colour raised in the French colony of Martinique where the educational system taught him he was French. However, when he moved to France to pursue further studies he was reminded all the time that he was black. White people always saw his skin colour and categorized him on that basis. Fanon writes that when he entered a room, "I feel, I see in those white faces that it is not a new man who has come in, but a new kind of man, a new genus. Why, it's a Negro!" (1967: 116).

Consciousness, then, is highly racialized and gendered. It is also highly attuned to markers of sexuality and social class. Even when we stop saying overtly racist, sexist, and homophobic things, in this unequal society we generally face a complex secondary process of dealing with the ways categories of class, gender, race/ethnicity, and sexuality frame our consciousness at levels of which we are not aware. It is not natural to sort people on first sight into these categories; it is the product of a society in which the relations of gender, race/ethnicity, sexuality, and social class are very important. Even people who think they practice "colour-blind" interaction, for example, often have a highly racialized consciousness.

Thus, phenomenology provides us with valuable tools for understanding the way our real world is structured.

Thinking Point: Racial Profiling

The issue of racial profiling by police, airport security, and border guards is an important example of racialized consciousness. Racial profiling means that people get targeted on the basis of perceived membership in a group associated with particular stereotypes rather than anything they have done. A young Black man might get stopped by police simply for walking in a particular area. Anti-racist and human rights activists have complained about racial profiling by police for a long time. The issue has been even more prominent in the reaction to the destruction of the World Trade Centre on September 11, 2001. Some governments and policing agencies have sought to make racial profiling official policy rather than an unofficial practice.

Racial profiling works on an everyday level when a police officer or border guard identifies someone as a potential problem on the basis of characteristics like skin colour, hair, or style of dress. They may not be aware of the criteria they are using to define certain people as potential trouble-makers or how their classification system has developed on the basis of personal experiences and prejudices, conversation with other security officials, media coverage, statements by politicians, or at times explicit departmental directives.

The profiling of people of North African, Middle Eastern, or South Asian backgrounds and/or those perceived as religiously Islamic has been a human rights issue for a long time. It has sharply intensified since September 11, 2001. Alarm bells are now set off inside security officials' heads whenever they see certain items of clothing or particular racialized characteristics. They may not even be aware of the extent to which this is happening, as consciousness works beneath the radar as taken-for-granted activities rather than deliberate choices. As a result, people belonging to certain groups find themselves singled out for attention every time they come into contact with the security apparatus, while others are waved through with minimal scrutiny.

DREAMS AND THE
CONSTRUCTION OF REALITY

THERE ARE certain moments in the aver-
age day when we are more likely to become aware of the
workings of our consciousness. One of these is when we
wake up from slumber, whether from a night's sleep or from
a nap. At least some of the time, there is an overlap between
our dreams and our waking consciousness. The alarm clock
enters into the dream or we expect to find a character from
the dream in the room with us when we wake up.

All of us perform our own daily breeching experiments
when we wake up from a deep sleep. Marcel Proust bril-
liantly described this process of coming to consciousness in
his novel Swann's Way:

> But for me it was enough if, in my own bed, my sleep was
> so heavy as completely to relax my consciousness; for then
> I lost all sense of the place in which I had gone to sleep,
> and when I awoke at midnight, not knowing where I was,
> I could not be sure at first who I was.... (Proust 1999: 3)

Consciousness, then, helps us to locate ourselves in the
world. Without that, we do not know ourselves. The world
then becomes unfixed:

> Perhaps the immobility of the things that surround us is
> forced upon them by our conviction that they are them-
> selves, and not anything else, and by the immobility of
> our conceptions of them. For it always happened that
> when I awoke like this, and my mind struggled in an
> unsuccessful attempt to discover where I was, everything
> would be moving round me through the darkness: things,
> places, years. (Proust 1999: 4)

Things that we normally think of as fixed may seem fluid as
we wake up. This is a reminder that the solidity of things is

not given by the outside world, but constructed in our consciousness.

Walter Benjamin invites us to go one step further and inquire whether our everyday consciousness does actually represent a state of awakeness. He raises the possibility that in contemporary capitalist societies we live our daily lives in shared dream-worlds. Benjamin (1999: 389) writes: "The situation of consciousness as patterned and checkered by sleep and waking need only be transferred from the individual to the collective." This is a provocative notion that we collectively sleep-walk through our daily lives, dreaming of the better life that will come when we win the lottery, buy the right clothes, use the newest cleansers, or drive the coolest cars. The dream-world is shared and therefore invisible to each of us as individuals.

If we share a collective dream-world, as Benjamin argues, then awakening would be a collective and not just an individual activity. Following Benjamin's argument, then, we could say that people tend to wake themselves up collectively when they enter into activism as a movement. They begin to see things clearly that were never so obvious before. Things that had seemed to be outside of their control, rather like the weather, suddenly seem to be products of human activity that they can challenge. So often the news can seem just like the weather report—storms are blowing in, and there is nothing you can do about it except buy an umbrella. As people collectively awaken, the news can become a challenge to act.

This is a big challenge to our everyday assumptions about reality. We might think that everything is real when we are awake and walking through the mall. Walter Benjamin invites us to consider the possibility that we are sleep-walking through a collective dream state in which we imagine that these consumer goods will actually deliver us from the humdrum existence of our daily lives.

REALITY AND THE UNDERSIDE

THE IDEA of the "real world" is sometimes used to refer to the grim underside of the collective dream-worlds we inhabit. In this view, it is the rough parts of society that remind us of the real world that is disguised in our consumerist fantasies. That is certainly some of the impulse of the American literary and film genre referred to as "noir." The idea of noir is to focus on the creepy realities that underpin the world of the American dream. Mike Davis (1992: 18-22) points out that Los Angeles is both the centre of the American cinematic dream machine and the dominant location for the noir genre, whether in the detective fiction of Raymond Chandler or in movies like Chinatown or Blade Runner.

Franklin Flyer, written by Nicholas Christopher, is a recent novel written with a noir sensibility. In it, Violetta describes her husband Joe, who is an underworld gangster: "He operates in the real world—the one beneath all the shifting, shining surfaces. He sees clearly in that world, the way a cat can see in the dark" (Christopher 2002: 165). Another character asks, "And you believe that is truly the real world?" Violetta answers, "Now more than ever. Look around: the bastards who want hell on earth are getting their way—and taking the rest of us along for the ride" (Christopher 2002: 166).

Is the real world, then, the gritty underbelly of crime and pain? Theoretical thinking opens up these questions, but the answer depends on your own convictions about how the world works and how it might change. Indeed, even the idea of what defines the real world can seem very different as time moves on. In the 1960s, student activists demanded that education be made relevant to the real world, which at that time of widespread social movement activism often meant useful in struggles for social justice. In contrast, at the beginning of the twenty-first century the idea of an education relevant to the real world is often defined in terms of specific preparation for the job market. Today, we would not be likely to see a

government report that argued as the Hall-Dennis report did in 1968:

> The society whose educational system gives priority to the economic over the spiritual and emotional needs of man defines its citizens in terms of economic units and in doing so debases them. (Provincial Committee on Aims and Objectives of Education in the Schools of Ontario 1968: 27)

It is worth wondering how it has come to pass that one area of our existence, the economic, becomes defined as the "real world" while others (community, family, friends, leisure, personal development, politics) do not. The idea of the real world is, in short, charged with all kinds of content. The more aware you are of the layers of meaning that surround the concept, the more you can discuss the real world with insight. This chapter will help you assess the ways that theoretical thinking may lead you to ask new questions about the reality around you and your own role in constructing it.

COMPETING REALITIES

THE CONSTRUCTION of reality in the world becomes particularly charged when we consider how it defines the horizons of possibility for our actions. The conflict and social order models provide contending visions of workings of the world that frame our understanding of what is realistic to expect in a particular situation. One model's hard-headed realism might seem like idealistic nonsense from the other's perspective. Gigantic tax cuts are the realistic solution to all of our problems from the point of view of some, while others think those cuts will only make things worse for much of the population.

The political debate over globalization over the last 10 years has been, in part, a debate about what is realistic. One

side believes that jumping in to the globalized world economy with both feet is the only realistic option, since we are seeing an inevitable trend that we cannot challenge. The other argues that it is possible to resist these pressures because forces exist to make a better reality.

Globalization describes a set of changes in the operation of the world economy over the past 30 years, including shifts in the patterns of trade, production, investment, and international relations. There has been a great deal of debate about its costs and benefits. The social order and conflict models frame our understanding of contemporary globalization in very different ways and offer contending perspectives on whether it is realistic to accept the inevitable progress of globalization or to mobilize against it. You should try to figure out which of the arguments below fits with the conflict model and which with the social order model, referring back to the discussion of the two perspectives in Chapter 1. Your goal here should be to clarify the basis upon which you link the argument to the appropriate model, finding as many details as possible that fit the core logic of the approach.

Argument A: A Better World is Realistic

In this view, it is realistic to fight back against the forces of globalization, which is a political strategy that strengthens the position of the most powerful nations and corporations at the expense of the disadvantaged. The reality of globalization is an increasing gap between rich and poor, within and between nations. It is a myth that globalization is about lowering barriers between nations and uniting us all in a new society that spans the globe and benefits us all.

The reality is that obstacles to the movement of people across borders have actually increased over the last 30 years, with the very specific exception of agreements such as the European Union that allow increased mobility within a region for those who are already on the inside. The power of corporations to invest wherever they choose has been

increased, but the ability of people to move has been limited by more restrictive immigration controls and refugee laws.

Globalization has stripped away some of the limited protection disadvantaged people had won from the ups and downs of the world economy, such as subsidies on key food-stuffs in Mexico that made them affordable for the poorer sections of the population. Meanwhile, subsidies of hundreds of millions of dollars flow to corporations to lure auto plants to particular jurisdictions.

The shift in power towards corporations is also reinforced in trade agreements like the North American Free Trade Agreement (NAFTA), which include provisions that allow companies to sue governments to overturn democratic decisions that might hamper the ability to make profits. The decisions on these suits are made by secret tribunals. The prime imperative driving globalization is to reduce impediments to profit-making in whatever form they might appear.

The forces that favour globalization are powerful indeed, yet that does not mean that the process cannot be contested. In France, Argentina, and Bolivia people have fought back and forced governments to overturn new policies aligned with the process of globalization. Demonstrations have greeted almost every multilateral meeting aimed at promoting the globalization agenda. The powerful have found a new strategy in globalization that strengthens their position, but the disadvantaged have the potential over time to develop new forms of resistance to assert their own power. That potential is the basis for a realistic sense that a better world is possible.

Argument B: Get Real: Globalization is Inevitable

Resistance to globalization is as futile as mobilizing for round-the-clock sunshine to keep the streets safer. There is a new reality out there, and our choice is to join in or get left behind. Globalization provides an opportunity to export the benefits of modern industrial society around the world. The best way to help the people of the poorer nations is to allow

them a competitive place in the world market. Previously, trade barriers served to insulate the economies of the most developed countries from competition. At the same time, Soviet-style economic measures focussed around state control limited the economic development of many of the less developed nations.

Globalization combines the opening up of the economies of the less developed nations with new trade agreements that increase the global circulation of goods and investment. Over time, this will provide people in the poorer nations the opportunity to advance. There might be some short-term dislocation effects, but these temporary setbacks will be overcome as modern economies develop and thrive around the world.

The move towards globalization is the result of tremendous technological advances, including the computer, the spread of air travel, and breakthroughs in telecommunications. As a result, information, goods, and people can travel the globe more quickly than ever before. These technological breakthroughs have corresponded to political openings associated with the fall of the Soviet Union and the shift of China towards open economic development.

There are always those who oppose progress and try to keep things the way they used to be. Globalization offers unprecedented opportunities for trade and development. It must be given a chance to work. Investment and trade are the basis for a future of economic growth that will raise the conditions of life of humanity around the planet. Those who choose not to participate will be left behind in economic and political backwaters. It may not be pretty, but that is reality.

Activity 2: Charting Contrasts

Activity 2.1 in the previous chapter ended with an annotated list of points from two sample arguments, each linked to the premises of either the conflict or social order models. This activity takes another step in the development of a piece of writing. We have to start by repeating the same analysis of the two sample arguments above as you performed in the

previous chapter, so that you end up with a list of the key points from each argument and the links back to the premises of one model or the other.

The challenge of turning this into a paper is that you now have a list of many points. A paper, though, should make one main point. The various points you have made on your pieces of paper need to be organized around one key theme, so that they become elaborations of a core argument rather than a series of independent points.

The challenge, then, is to find a way to move from a series of points to a central argument. One of the steps in that direction is to refine your two pages to make a single chart in which you establish the contrast between the two sample arguments on a point-by-point basis and relate that back to the contrasting premises of the two models. You have now reduced the total number of points from two lists to one series of clear contrasts. That is an important step in the right direction.

Exercises

1. Go out in a small group and sit together in a cafeteria or a similar crowded location. For a 5 minute period, each of you should try to document every sensation (sight, sound, smell, taste, feeling) you perceive. Compare notes and discuss the differences. How did you feel at the end of the 2 minutes?

2. In a small group, design a breeching experiment that will make people aware of the way they have constructed a particular situation. Discuss specifically what aspects of consciousness you hope they will notice. Report back to the class and have a discussion on whether your strategy would work.

3. Keep a pad of paper by your bed and take notes of your feelings as you wake up three different times. Try to nap at an unusual time or in an unusual place for one of the times. Bring your record to class and discuss the ways that cycles of sleep and waking can make you aware of the way consciousness works.

4. Analyse the film "The Matrix" in terms of the ideas of consciousness raised in this chapter.

5. Find an article or book outlining a position on the globalization debate. First, identify salient facts, theories, and opinions in the article. Secondly, make an argument about why the case the writer makes fits more with the conflict or social order model outlined here.

4

Nature and Culture:
The Social Construction
of Distinctions

N ATURE IS one of the key concepts that frames the perspectives of many social theories. Most theories have a central vision of human nature and assumptions about our relationship with the environment we find ourselves living in. This chapter begins with a discussion of the relationship between nature and culture in our understanding of the human experience.

The way we see the relationship between nature and culture underpins our vision of human nature, the core characteristics of people across time and through space. Every theoretical school is based on a set of assumptions about the core constituents of human nature.

The whole question of what is natural in human behaviour is hotly debated. After all, the things that are natural might be thought to be impossible to change through conscious activity. Death, for example, is a prime fact of life, and no amount of human activity will ever overcome it. Theories often naturalize—treat products of human activity—as if they were products of immutable natural forces. The whole discussion of nature in the early twenty-first century necessarily raises the questions of ecology and the health of our environment. Theory can cast environmental change as something we can work on or as an inevitable fact of life.

This chapter concludes with sample arguments that view the social world through the lens of natural models developed in the natural sciences, which have had a huge influence on the humanities and social sciences. These arguments show how both conflict and social order models have picked up conceptual tools from the natural sciences.

THE REASONS WE COOK

IF YOU think back on everything you ate over the last 24 hours there is a good chance that much of it was cooked. We cook or process so much of our food that it seems obvious to do so. People claim that food tastes better or is healthier when cooked. Yet many foods lose valuable nutrients through the cooking process, and the preference for raw or cooked food is highly subjective. Fish can be eaten raw (sushi), steak can be eaten raw (steak tartare), and we all know that carrots can be eaten raw. Yet, we persist in cooking many foods that can be eaten raw.

The anthropologist Claude Lévi-Strauss (1969) argues that cooking is primarily a symbolic process through which we translate foodstuffs from the realm of nature (raw) to the realm of culture (cooked). Cooking food is, after all, a uniquely human characteristic. In the world of nature there is no other species that processes what it eats in a similar way. Lévi-Strauss suggests that this symbolic dimension to cooking is far more important than any ideas of taste or health, which follow upon this symbolic process of making food into culture.

So, cooking is a process by which we transform the things we are about to eat from nature to culture. This establishes a symbolic relationship between the cultural and the natural. Indeed, Lévi-Strauss says that all human cultures seek to locate themselves relative to nature in many of their most common practices. He is a structuralist theorist who argues that the most important dimensions of social practices are often not visible to those who participate in them. Underlying the stated goals of many social practices is the deep symbolic code reproducing the notion that culture is superior to nature. People might explain their surface reasons for cooking food, cutting hair, or wearing clothes, but underlying their explanations is a shared commitment to practices that stake claims for the superiority of the cultural over the natural.

Sherry Ortner (1974) points out that this relationship of culture and nature has distinct implications for our understanding of gender. The symbolic systems that rank culture above nature also rank men above women, as it is assumed that women are closer to nature due to their association with child-birth and breast-feeding. One of the sources of sexist and patriarchal assumptions is therefore this practice of valuing the cultural above the natural.

At a time when we are becoming ever more aware of the ecological costs of certain human practices, it is certainly important to investigate whether some of our core cultural assumptions put us on a collision course with the earth by devaluing the natural. There are, of course, great debates about the theories of Lévi-Strauss and the idea of deep cultural meanings that operate beneath the awareness of human actors. And there are certainly great debates about the relationship between culture and nature.

Indeed, one of the central debates within the humanities and social sciences is about the relationship between nature and the human condition. The nature/nurture discussion about the relative influence of genetic heritage and cultural upbringing on the development of the individual is just one example of this multi-faceted debate. The fundamental premises of all social theories include certain assumptions about the relationship between humanity and nature. The idea of "human nature" is also regularly debated in the political sphere, where policies ranging from welfare cuts to tougher criminal sentences are justified in terms of the fundamental motivational structure presumed to underlie all human actions.

It is not my aim in this chapter to definitively resolve these debates about nature and culture. Rather, I want to show the way that theoretical reflection disturbs our easy assumptions about this relationship. For example, it is important to think about whether or not there is any meaningful boundary between nature and culture, or whether all cultural activity is "natural."

GOING AGAINST NATURE

THE IDEA that certain practices are unnatural for humans is frequently expressed in ethical debates about norms and regulations. For example, people opposed to homosexuality often describe same-sex sexual practices as "unnatural." The extent to which human sexual practices are natural and/or cultural plays a large part in debates about the regulation of sexuality. For instance, some argue that sexual restraint is cultural, distinguishing us from other species that respond to the urges of heat by indiscriminate sexual activity. Others argue that heterosexuality is natural, though it is pretty hard to argue that any particular sexual mode predominates throughout the natural world.

Our thinking about nature and culture often operates on the assumption that these are separate and opposed. Human culture, however, can be understood as a product of evolution governed by natural laws, which produced a species with the capacity, indeed the need, for culture. There is nothing "unnatural" about culture, as it is itself a part of nature. It does not really make sense, then, to label certain human practices as "unnatural." The idea that what is cultural is by definition also natural is an important challenge to the standard assumptions we make about nature and culture.

Terry Eagleton (2000: 1) in his study of the history of English words, points out that the term "culture" derived from ideas of nature. The term originally described human work on nature to shape spontaneous growth: "We derive our word for the finest of human activities from labour and agriculture, crops and cultivation." The idea of culture originated as a description for the activity of cultivation, the process of intervening in natural growth processes to have an impact on the outcome, such as more wheat and fewer "weeds." There are, of course, no "weeds" in nature—that is a completely human-oriented term to describe the natural growth we determine to be inconvenient.

The term culture, then, presumes a relationship with nature from the outset, according to Eagleton (2000: 3): "Nature produces culture which changes nature...." There is, then, nothing strictly "unnatural" about the development of a city, which is merely a particular act of cultivation in which raw materials are brought together in particular ways to make streets and buildings (see Eagleton 2000: 4). Even the most artificial synthetics grow out of human work on the natural world (extracting, recombining, synthesizing).

The term "culture" is therefore very rich, as it refers to the complex interchange between conscious human actors and their natural environment. Eagleton (2000: 5) writes: "Human beings are not mere products of their environs, but neither are these environs sheer clay for their self-fashioning. If culture transfigures nature, it is a project to which nature sets rigorous limits." Humans do not, for example, override the laws of gravity when they fly, but work within them to produce levitation. In this sense, human action involves important components of agency (work on the environment to meet one's own goals) and determinism (the overriding impact of the environment due to the unalterable character of certain structural conditions).

HUMAN NATURE

O NE OF the areas where discussions of the relationship between culture and nature are particularly important is in debates around human nature. These debates raise the issues of the essence of the human condition and the extent to which this is biologically given or socially constructed. We all tend to make assumptions about human nature all the time in our interactions, which are based on our attributing to others varying degrees of trust, love, generosity, suspicion, hatred, or greed.

One of the views of human nature that is most influential in contemporary North American debates is reflected in the

novel *Lord of the Flies*, which I discussed briefly in Chapter
1. In this view, society is the thin civilizing line that protects
people from their own worst selves, which are fearful, greedy,
impulsive, and susceptible to melting into a violent mindless
mass. Conservative political movements and politicians fre-
quently invoke this view of humanity to justify law and order
regimes and military conquests.

Lord of the Flies traces the experiences of a group of chil-
dren who find themselves alone on a deserted island. At first
it's a dream-world without adult authority. Early on a boy
named Ralph says with a smile "No grown-ups" (Golding
1958: 8). But in the absence of that adult authority, things
go rotten pretty quickly. They miss being rescued because the
signal fire went out when the fire-tenders left their posts to
go hunting (1958: 75). Most of the boys join into a murder-
ous mass, chanting "Kill the beast! Cut his throat! Spill his
blood!" (1958: 168) as they kill a boy.

The naval officer who finally rescues them is a bit shocked
at the condition of these British boys: "I should have thought
that a pack of British boys—you're all British aren't you?—
would have been able to put up a better show than that.... "
Ralph replies, "It was like that at first ... before things—"
(Golding 1958: 222). This image of Britishness as the thin
civilizing line flows through the book, revealing the racist as-
sumptions underlying this view of human nature that divides
people into civilized and savage. At one point, Piggy asks
"Which is better—to be a pack of painted niggers like you
are or to be sensible like Ralph is?" (Golding 1958: 199).

In this view of human nature, children must be civilized by
years of socialization to learn to restrain the "savage" within
and live by the rules. Children are dangerous because they
have not yet been domesticated. Adult supervision is crucial
at all times to protect children from their own impulses.

A very different view of human nature is presented in
Marge Piercy's (1979) novel *Woman on the Edge of Time*.
This book explores a utopian society envisioned by a woman
who is actually locked in an asylum. Here, the children are
given as much freedom as possible in a nurturing atmosphere

to explore the world and create themselves as a person. They do not go to school, but mix freely with adults and play at many activities to learn by engaging with their environment. In this way, children and adults are constantly learning:

> But who wants to grow up with a head full of facts in boxes? We never leave school and go to work. We're always working and always studying. We think, what a person thinks [she or he] knows has to be tried out all the time, placed against what people need. We care a lot about *how* things are done. (Piercy 1979: 131)

The visitor from the present wonders how someone can do repair work with a "mob of kids underfoot." The guide from this utopia replies, "A mob of kids?.... We think about kids so differently it makes us crosstalk, my friend.... We ask a lot of our children but ... politely" (Piercy 1979: 132).

In this view of human nature, society is seen as a enabling, but also potentially restricting, the creativity of the child and of the person. When the visitor from our time hears that children set out on their own at age 12 to pursue a vision quest in the woods she is outraged. Her guide replies:

> We haven't misplaced a child yet. You're right, accidents happen.... But why try to control everything? ... [W]e think control interferes with pleasure and with communing and we care about both. (Piercy 1979: 117)

In *Lord of the Flies*, human nature threatens to slip out of control if it is not properly regulated by society. In contrast, in *Woman on the Edge of Time*, social control threatens to stifle the creativity that is the essence of human nature. These fundamentally opposed visions of human nature are connected to very different views of education, politics, and social theory.

There are, then, strongly opposed visions of human nature that underlie our everyday understandings of nature and culture. It is worth spending some time trying to understand

your own vision of human nature; it likely has a significant impact on your political assumptions and your interpersonal behaviour. One of the most important features of effective theoretical thinking is that is makes us more aware of our own key assumptions when looking at the world and helps us understand those of others.

Thinking Point: Debates about Human Nature

It is often easy to stir up a fairly intense debate about approaches to crime and law enforcement. Some people believe very strongly in capital punishment, tough sentences, and firm police actions. Others oppose capital punishment, support rehabilitation, and are suspicious of police power. These positions are often based on fundamental assumptions about human nature.

Those who favour capital punishment, stricter sentences, and more policing tend to be fairly pessimistic about the possibility of reforming lawbreakers, assuming that patterns of criminality are quite firmly set and difficult to change. This view of criminality often builds on ideas that socialization is the only thing that tames humans, who otherwise would be quite savage and beastly. The criminal is the beast who comes to the surface due to a failure of socialization, either because the agents of society (parents, schools, etc.) failed or because the individual has a particularly savage nature. In any case, by time the behaviour has reached the point of criminality, there is little that can be done but to restrain the beast.

In contrast, those who are suspicious of law enforcement tend to be more optimistic about rehabilitation, assuming that the human being is fairly plastic, susceptible to being molded and remolded by effective agencies of society. This perspective is founded on the premise that humans are creative and social beings who become dangerous only when they have been brutalized by individuals or social institutions. One of the dangers of an oppressive society from this perspective is that it breeds brutalization, for example, in the prison. The aim, therefore, is to intervene in processes of socialization to reshape the person in a more positive, pro-social (as opposed to anti-social) direction.

In these debates about law enforcement people often talk past one another because their fundamental assumptions are so different that there is little common ground for discussion. These conflicting perspectives on human nature often resurface in debates about education, poverty, housing, and the family. The question of whether the goal is to overcome the beast within or to unleash potential creative powers underlies many of our discussions.

NATURALIZATION

THE CONCEPT of human nature is a powerful reference point in many debates about politics and society. One of the most important ways that this happens is through the "naturalization" of social conditions associated with a particular kind of social structure at a particular moment in time. Naturalization means treating products of human action as if they were the inevitable outcome of natural laws beyond our control.

One of the major features of racism, for example, is that it naturalizes differences that are a product of particular social and cultural circumstances. Stuart Hall (1999a: 445) writes that racism "operates by constructing impassable symbolic boundaries between racially-constituted categories ... and attempts to fix and naturalize the difference between belonging and otherness." A particular colour of skin or type of hair is taken as the symbolic marker of who really belongs here and who is an outsider (even after generations). Following Hall, we could argue that racism in Canada is premised on these ideas of belonging and otherness, in that some people are seen as more naturally "Canadian" than others. This is not simply based on seniority, as Aboriginal people have historically been excluded from Canadianness through the destruction of their own cultures and marginalized status. It is based on a particular series of historical events and conquests that developed a particular power structure associated with specific ideas of whiteness.

Naturalization treats human categories as fixed features of the natural world, not subject to change. This can create a sense of resignation, an acceptance of conditions as they are. If it is going to rain tomorrow, there is little I can do but carry an umbrella. It is absolutely futile to rage at the weather, organize a protest movement, or vote for those candidates who promise warmth and sunshine in the middle of a northern winter. However, if a plant is being closed, or a dangerous chemical is discharged into the air or water, or a

person is being deported or evicted, someone somewhere is making a decision. As long as there are human beings making decisions, it is always at least hypothetically possible that others can have some impact. The weather, in contrast, is not produced by human decisions, though it is possible that the long-term impact of human actions is changing the world's weather map. In that case, global warming is a product of human decisions and therefore susceptible to social action, while tomorrow's weather is not a result of our activities and therefore cannot be changed by us.

Naturalization can occur in times when there is not a lot of protest action around, when it may feel futile to try to change things, rather like demonstrating against a rainy day. In these circumstances, naturalization takes place because people resign themselves to the way things are. Nigel Harris (1971: 57) writes that this comes from the perception of powerlessness, "which usually underpins what is called 'apathy,' the knowledge that no action by oneself can change matters." The condition that upsets us begins to appear to be part of the natural order, just like the weather, in that there seems to be nothing that can be done about it.

Naturalization can therefore be an important component of ideologies. "Ideology" is a highly contentious term in social theory (see Bailey and Gayle 2003). Here, I will define ideologies as the explanatory frameworks used by particular social groups (such as ethnic groups and social classes) to guide their action in the world (see Hall 1999b: 26). Ideologies base a system of thought on an interpretation of the way the world looks from a particular social position. As we discussed in Chapter 2, for example, the classroom might look different from the position of a teacher or a student. Similarly, you look at a fast food restaurant in a very different way if you were there as a customer, a worker, or a visiting executive from head office.

Ideologies systematize and package the insights that can be obtained from a particular perspective, for example, that of labour or management. A pro-management ideology might base its world view on the claim that everyone gains

advantages through economic growth based on rising productivity and cost savings to gain international competitiveness. In contrast, a pro-labour ideology might focus on the costs workers bear for that increased productivity, for example, in the form of lay-offs, increased injury rates, or greater stress. The process of systematizing and packaging these ideologies involves important elements of interpretation, as certain features are highlighted and others ignored.

Naturalization is a common feature of such ideological perspectives. A pro-management ideology might treat the competitive environment rather like the weather (there is nothing we can do about it) and therefore frame our reality in such a way that we see productivity increases and cost savings as inevitable. A plant might have to be closed, or the pensions of retired people dramatically cut, but that is simply the cost of doing business, and there is no other way. At the same time, the advocates who fight to save jobs and pensions might be criticized from a pro-management perspective for naturalizing entitlements, assuming workers have a right to a job and a pension, regardless of their own productivity or the overall health of the economy.

Ideologies often seem completely false from the perspective of those who oppose them and absolutely true to their advocates. The reality is often more complex—ideologies that have power to grip people tend to have some sort of real basis even if that is combined with elements of distortion based on partiality. There are two important distortions that often distinguish ideologies: eternalization and naturalization (Hall 1999b: 33). Naturalization, as we have already discussed, consists of treating the outcome of human actions as if they were products of nature rather than of particular historical processes. Eternalization is the claim that a condition arising in particular circumstance at a particular moment is true for all time. For example, some people claim that it is natural for humans to be greedy and selfish, basing that argument on observations of the ways we behave in an industrial capitalist society where acquisitiveness is highly prized. Greed has not necessarily played the same role in some of the other cultures

anthropologists study, where orientation towards the group as opposed to the individual is the crucial basis of human interaction.

Thinking Point: The Ideology of Laziness

"Students are lazy." It is quite common to hear this complaint from professors. Many university teachers feel that students who miss classes, read as little as possible of the course material, and do minimal work on their assignments are lazy. Yet these same students might be highly motivated in the gym, at their job, or in a club. Their laziness may, in short, be situational rather than general. That situational laziness may result from a lack of interest in the subject matter, or a feeling that it does not matter whether or not you are actually in class since very little seems to happen there, or a sense that passing is sufficient to get the degree and that is what is important.

The claim that students are lazy is rooted in the larger ideological premise, which holds that people are fundamentally disinclined to work. This premise seems to be confirmed every time someone is seen leaning on a shovel rather than digging with it, cheating on an assignment by downloading it rather than doing the work, or chatting with a friend on the phone when a customer is wanting service. It seems that people need to be motivated by money or grades or fear or some other external factor.

The ideological premise that people are lazy often includes elements of naturalization and eternalization. Laziness is naturalized when it is seen as a fundamental characteristic of the species, a part of human nature. In this view, the in-built goal of humans is to minimize effort. The eternalization of laziness occurs when we assume that a pattern of action in a particular moment is the product of an impulse that is there for all time. Thus, students who do only the bare minimum of work in a university course are taken as indicators that the flight from work is a permanent feature of the human condition.

The discussion of abstraction in Chapter 2 examined how particular concepts get framed, focussing on the dimensions of extension (coverage of time and place), level of generality, and point of view. Ideologies frame concepts like laziness in particular ways. Theoretical thinking involves the ability to understand the ways key concepts are framed in particular discussions.

ECOLOGY

I N H E R novel *O Pioneers!*, originally published in 1913, Willa Cather portrays the experiences of white settlers in the plains of Nebraska. Early on, she records the dismay of a young boy whose family was just arriving:

> But the great fact was the land itself, which seemed to overwhelm the little beginnings of human society that struggled in its somber wastes. It was from facing this vast hardness that the boy's mouth had become so bitter; because he felt that men were too weak to make any mark here, that the land wanted to be alone, to preserve its own fierce strength, its peculiar, savage kind of beauty, its uninterrupted mournfulness. (Cather 1993: 5-6)

Of course, the aloneness of the land was largely an artifact of the white viewpoint that refused to see Aboriginal peoples and their prior relationship with it. Nonetheless, this portrait is a reminder that the land can seem greater than humanity and nature a more potent force than culture.

At the beginning of the twenty-first century, it is hard to credit the land with this power. Certainly, there are moments when the grandeur of the land and the force of nature seem awesome. But in the age of the atomic bomb, environmental devastation, and greenhouse-induced global warming, mother earth is looking a bit vulnerable these days. Over the course of the twentieth century, something happened in human relations with the planet and in the social consciousness of that relationship. The combination of social and technological change has produced a situation in which we have a unique responsibility for the health of the planet, whether we wish to assume it or not. Rachel Carson's (1962) pioneering book *Silent Spring* was a pathfinder in the development of a new awareness of the hazards people were creating, and it spawned activism against pollution and the degradation of the environment.

Humanity has a huge responsibility for the ecology of the planet at the beginning of the this century. David Harvey (2000: 120) clarifies:

> A strong case can be made that the humanly-induced environmental transformations now under way are larger scale, riskier, and more far reaching and complex in their implications (materially, spiritually, aesthetically) than ever before in human history…. The quantitative shifts that have occurred in the last half of the twentieth century in, for example, scientific knowledge and engineering capacities, industrial output, waste generation, invention of new chemical compounds, urbanization, population growth, international trade, fossil fuel consumption, resource extraction, habitat modification—just to name some of the most important features—imply a qualitative shift in environmental impacts and potential unintended consequences that require a comparable qualitative shift in our responses and our thinking.

That is quite a list, and he did not even discuss nuclear, chemical, or biological weapons.

It is, however, misleading to discuss the responsibility of humanity (as I did above) in ways that make it sound as if all people bear this weight equally. Eduardo Galeano (2001: 216) makes this case strongly: "The state of the world's health is disgusting, and official rhetoric extrapolates in order to absolve: 'We are all responsible' is the lie technocrats offer and politicians repeat, meaning no one is responsible." The consumption of the wealthier nations of the earth is massively out of proportion with that of the rest of humanity, creating a huge environmental toll. Galeano (2001: 223) illustrates this with the example of the flower industry: "Columbia grow tulips and roses for Germany…. When the flowers are ready, Holland gets the tulips, Germany gets the roses, and Colombia gets lower wages, damaged land and poisoned water."

Harvey (2000: 221) writes: " ... environmental impacts frequently have a social bias (class, racial and gender discriminations are evident in, say, the location of toxic waste sites and the global impacts of resource depletion or environmental degradation)." If you map exposures to dangerous substances, toxic dump sites and hazardous processes, you find patterns that show, for example, that working-class people, people of colour, and people in the countries of the developing world face the gravest dangers and get the fewest benefits.

Cancer, for example, frequently results from environmental exposures. Those on the front-line for these exposures are disproportionately working-class people, people of colour, and people living in poverty. Matthew Firth, James Brophy, and Margaret Keith (1997: 2) claim that "Cancer is clearly a disease that affects workers and the economically disadvantaged more than other sectors of society." The impact of environmental degradation follows the contours of existing structures of social inequality. Those theorists who argue that the concept of social class is hopelessly outmoded in contemporary North American societies would do well to investigate the relative exposure levels of those who own and control the workplace and those who work in it.

The relationship between culture and nature is a charged one at the beginning of this century. Humans have, through our culture, developed the productive capacity to transform the face of the planet. Humans alone can turn huge valleys into lakes to make hydroelectric power or produce sufficient quantities of greenhouse gases to threaten the integrity of the earth's environment. It is a uniquely human situation to bear the responsibility for the survival or extinction of whole species, including potentially our own.

This does not mean that humans are above nature; we are still part of it and subject to its laws. Yet, we are a unique part as a result of the capacities we have developed through our culture to make our mark. This leaves us with a tremendous responsibility to reflect and act on the relationship between

nature and culture. Theoretical thinking can help prepare us for this work.

NOTHING MORE NATURAL
THAN CULTURE

THERE IS nothing new in the view that separates nature from culture. Stephen Jay Gould (2002: 230) points to the human habit of seeking to distinguish ourselves from nature, which he describes as "dichotomization, or division into two opposite categories, usually with attributions of value expressed as good or bad, or higher and lower." As a result of that division we have sought for "a 'golden barrier,' a firm criterion to mark an unbridgeable gap between the mentality and behaviour of humans and all other creatures"(Gould 2002: 230).

Theoretical thinking helps us unpack the dichotomies that shape our thinking on many issues. There is a wide range of theoretical analyses on the relationship of nature to culture, from those who believe that, since culture is reducible to nature, we can simply understand human behaviour in biological terms to those who believe that culture is distinct from nature and can only be understood in terms of a specific set of humanities and social sciences. It is also possible to argue that culture is a part of nature that bestows on people unique capacities to transform the environment.

Good theoretical thinking denaturalizes—it melts the lines of distinction that we take for granted in our everyday reflection on the world and raises debates about where such lines might be drawn. This may seem tedious and unnecessary, a detailed investigation of things we already know. The challenge in theoretical thinking is to examine things we think we already know with open eyes, so that we are prepared to be surprised. This does not mean giving up the perspectives and experiences that make us who we are, but rather encourages us to take up a new kind of self-reflection so that we become

more aware of the assumptions that frame our own vision of the world.

One of the most influential methods for theoretical reflection on social reality is to use models derived from the observation of the natural world. Indeed, as discussed in Chapter 1, there has been an ongoing circulation of models back and forth between the natural sciences, on the one hand, and the humanities and social sciences on the other. Darwin's conception of nature, which had a huge influence on social theory, was itself influenced by the political economy theories of Thomas Malthus.

CHANGE IN THE NATURAL AND SOCIAL WORLDS

Finally, it is worth asking in a broad sense why one might seek to understand social change through the use of analogies to the natural world. On the one hand, the social world is part of the natural world, and so it certainly makes sense to imagine that it might change in accordance with the laws of nature. At the same time, social change can be regarded as a special case within the natural world in that conscious activity might play a particularly important part.

Evolution in nature does not occur because of any conscious activity on the part of the species involved. In contrast, people are capable of changing the social world according to conscious projects. Apartheid in South Africa, it can be argued, was ended because of the increasingly militant activity of Blacks who refused to accept the racist order. New trade unions were formed, activist community organizations were developed, and a whole gamut of political groups thrived in a vibrant (and sometimes violent) atmosphere of mobilization and debate. We be able to understand the conscious dimensions of political and social change only through such specific models that do not apply to the rest of the natural world.

At the same time, not all theorists necessarily agree that conscious human agency is a crucial part of change in society. There are theorists who argue that humans are not capable of consciously changing the world, but rather that processes of social change involve outcomes that were never intended by the actors involved. Theorists might argue that the natural world offers up useful models of change without a defined purpose.

Both the conflict and social order models have drawn upon concepts developed for the theoretical understanding of the natural world. These have provided useful tools for understanding processes of stability and social change. Further, these concepts carry with them some of the authority of the natural sciences. Again, your challenge is to identify the dimensions that link each of these arguments to either the conflict or social order models.

Argument A: The Organic Analogy: Differentiation and Integration

There is a long lineage of social theorists who have argued that the workings of society are analogous to those of an organism. An analogy draws a parallel between two phenomena, reasoning that what happens in one case will also happen in the other when crucial elements are similar. The organic analogy has provided important tools for understanding interdependence, equilibrium, and evolutionary change in modern industrial societies.

This organic analogy began as a simple model of interdependence. Just as the human body has differentiated organs (brain, lungs, heart) that can only survive by working together, so society has developed a series of specialized institutions (religion, government, schools) that are different yet depend on each other for the survival of the whole. The development of the science of evolution through the 1800s inspired richer and more detailed versions of this organic analogy.

Theories of evolution, particularly those of Darwin, provided new materials for understanding the relationship

between equilibrium and change as well as new ways of understanding differentiation and integration. The Darwinian account of evolution provided tools for seeing changes as incremental steps towards constructive adaptation to the environment. Random variations in the reproduction of species produce mutations which occasionally yield individual organisms more likely than others to survive and reproduce. The new mutations, such as a slightly longer beak that makes it easier to get insects out of bark or a slight variation in colouring that provides better camouflage, then become more numerous as the individuals with those characteristics have the best chance of surviving and producing a new generation.

These random variations are not produced out of any desire for change on the part of the species involved, but are simply reproductive accidents. Indeed, in most cases these mutations provide individuals ill-suited for survival. Once in a while, though, the accident works for the better.

Over time, these accidents produce a natural world that is more highly differentiated and more integrated. The earliest life forms were simple one-celled organisms that were quite independent in that they could survive and reproduce on their own, without sex or any other interaction. As life forms became more complex, the cells within became more specialized and different from one another as well as more interdependent. A brain cell, for example, could not survive on its own if it were cast onto the pavement in an accident.

At another level, ecosystems developed more complexity. More species evolved, became more specialized and more interdependent, each occupying a very specific niche in the chain of life.

More complex ecosystems are thus no less stable than the simpler ones. Change can produce a new kind of stability rooted in equilibrium on the basis of differentiation and integration.

Argument B: Change Is the Only Constant

Darwinian evolution can also be used by theorists with a very different theoretical agenda than those in the argument above. Evolution in nature provides insights into the possibilities for dramatic change. In the first place, evolution refutes the idea of a hierarchical world arranged by God in which everyone and everything has its place. Instead, evolution is a physical process that unfolds without divine authority or grand idea.

Secondly, there are ways of understanding evolution that do not see progress as the result of relatively consistent gradual change. Evolution can also be seen as periods of general stability interrupted by moments of sharp and rapid change that turn the world upside down. Certain dramatic events, such as a major change in climate, produce a transformed eco-system marked by the extinction of many older species and the emergence of many new ones.

The natural world has seen a succession of ages, each one ending in a period of sharp transition. Evolutionary innovation tends to cluster in these periods of sharp transition, while change is more limited within each era. Each era has its own set of ecological relations and its own characteristic species.

This provides a basis for understanding social change as a convulsive process, a more sudden overturning in which the dominant relations no longer apply. This is a very different interpretation of change in the natural world. It raises the question of which of these models fits best the patterns of change in the natural world and also which fits the social world.

Activity 3: Finding Your Main Point

The two preceding chapters ended with activities to help you move in the direction of writing a paper that makes a point. The first was designed to help you read carefully so that you could develop an analysis of each argument leading to a list of points tied back to premises of either the conflict or social order model. The second moved you from two lists to

a single chart that established the key contrasts between the two arguments.

The first step in this exercise is to go through the two phases above, again focussing on the two sample arguments in this chapter. You will end up with a chart establishing the key points of contrast between them. The next step will be to figure out a way of explaining the pattern you have charted, identifying a key theme that ties all of the points of contrast together.

Now try to write two paragraphs of no more than 80 words each. The first paragraph should establish the key point of contrast between the two arguments above. The second should discuss how all the contrasts you have charted relate back to the key point of contrast you have identified. It might take a number of tries to find this key point of contrast. Discussion with someone else might help move you forward, as you can each provide a sounding board for the effectiveness of the other's explanations.

Exercises

1. In a small group, discuss how different aspects of human nature are brought forth in a disaster, such as an earthquake or an electrical blackout. What does this tell you about the idea of human nature?

2. Find an example of a different culture in which the core attitudes and values of people are very different, such as the hunter and gatherer or simple horticultural societies examined by anthropologists. Is there anything left that you assume might apply to all people in all cultures?

3. Find a newspaper report on a speech by a prominent politician. Try to identify elements of naturalization and eternalization in the analysis of events she or he offers.

5

Making Time: Clocking Social Relations

THIS CHAPTER begins with time, which seems to be the most natural of measures. After all, time passes in nature, lives begin and end, seasons change, the sun rises and sets. This chapter will show the ways that this apparently natural system is deeply rooted in our social relations.

Clock-time developed historically in the context of a specific set of changes to the way society worked. Our world has been organized around clock-time, which has required the development of a technical apparatus ranging from accurate time-pieces to a system of time zones.

The increased focus on clock-time might be understood in terms of technological progress. In this chapter, however, I argue that it is connected to particular power relations in society. The control over time has become a crucial means by which the powerful exercise their control over society. This whole issue seems particularly pressing given the great speed-up that seems to be intensifying our time use at the present moment. We are busy people and getting more so.

Theory helps us understand the issue of time by setting it in the context of history, the patterns of change over time. The clock that seems so central to our lives now was not so important even a couple of generations ago. Historical understanding helps us distinguish the eternal features of the human condition from those that change as society does.

The chapter concludes with sample arguments from the social order and conflict models that contrast the approaches to history associated with each. History is not simply an account of what happened back in the day, but also an interpretation of events framed by our assumptions about the

workings of the world. Different models therefore yield contrasting pictures of the same events.

As a teacher, I often notice students watching the clock in my classroom. It is usually a bit disheartening, as I do my best to keep things hopping. At the same time, I must confess that I have done my share of clock-watching in similar circumstances. One of the features of clock-watching is that time seems to go very slowly. You look again, and it seems that the clock hands have not moved at all.

In fact, the pace of time seems to vary a great deal in our daily lives. People telling the story of a car accident or a similar catastrophe will often say that time suddenly slowed down, the world went into slow motion. Meanwhile, a much-savoured weekend can fly right by so that before you know it you face yet another Monday morning. Julia Glass (2003: 194) expresses this beautifully in her novel *The Three Junes*:

> Time plays like an accordion in the way it can stretch out and compress itself in a thousand melodic ways. Months on end may pass blindingly in a quick series of chords, open-shut, together-apart; and then a single melancholy week may seem like a year's pining, one long unfolding note.

Time seems to move at a different pace, even though we know that the clock ticks on at exactly the same rate. Indeed, the clock is a machine designed to do exactly that. In contemporary industrial societies our lives are so organized around clock-time that we get lost without a timepiece—we don't know when to eat, go to bed, meet friends, catch a bus, show up for work, or get up in the morning. Yet, clock-time is a relatively recent development in human experience. A theoretical reflection on time reminds us of how something that seems so natural is actually a social construction reflecting a particular hierarchical organization of human affairs. It also ties the rise of the clock to the idea of change over time, the historical character of human experience.

THE RISE OF THE CLOCK

THE DANISH writer Peter Høeg offers a fascinating exploration of the meanings of time in his novel *Borderlines*. Time is central to this story about a few "problem" kids who are taken into a prestigious school as a grand experiment by the ambitious headmaster Biehl, who believes he has figured out the correct methods to tame the human spirit. At the core of this process of domestication is punctuality, life by the clock and the timed bell. The combination of the bells and the headmaster's watch "saturated the school with a finely meshed web of time" (Høeg 1995: 68).

This web of time is central to the project of taming spirits, capturing individuals within the imposed order of the school as surely as a net traps a wild animal. Those of us who have been raised in a culture organized around clock-time take our captivity in the web of time for granted. Yet Høeg reminds us that there is nothing natural about this process.

For most of human history, people experienced time in terms of natural cycles. They organized their work and leisure, sleep and waking on the basis of the daily cycle of light and dark, the annual cycle of the seasons, and the great cycle of life and death. Clock-time replaces nature's cycle with a time-line in which everything is organized chronologically as a single story of past, present, and future.

The invention of the mechanical clock did not immediately change the cyclical rhythm of life. Høeg suggests that the clock was not developed initially as a useful tool, but rather as a technical marvel. The presence of a mechanical clock in the town square had little impact on the lives of most people, who still lived their lives according to the rhythm of natural cycles:

> What fascinated people about the measurement of time was not time itself, because that was dictated by other factors.
>
> What fascinated them was the clock. (Høeg 1995: 64)

The clock itself was fascinating because it represented the workings of the universe in a new way. It was, therefore, "like a work of art, a product of the laboratory, a question" (Høeg 1995: 64). The clock represented a challenge, a puzzle, a symbol of great unknowable natural forces. But this changed. "The clock has stopped being a question. Instead it has become the answer" (Høeg 1995: 64). Clock-time becomes the answer to taming of the human spirit.

Høeg's novel explores the use of time, focussing on a fictitious school called Biehl's Academy. The story is narrated by the central character, who is one of the "problem" students in the school. He rebels in the end, using his resources to break out of the web of time and escape the discipline of the school. As he rebels, he reflects on how the school is organized around time. His analysis of the role of time becomes crucial as he tries to make sense of his own experiences inside the school and his escape from it. He eventually concludes that the school is a massive experiment in use of time management to tame the human spirit.

> I believe that Biehl's Academy was the last possible point in three hundred years of scientific development. At that place only linear time was permitted, all life and teaching at the school was arranged in accordance with this—the school buildings, environment, teachers, pupils, kitchens, plants, equipment, and everyday life were a mobile machine, a symbol of linear time. (Høeg 1995: 260-61)

In fact, the use of time in Biehl's Academy is rather typical of the places that Erving Goffman (1961) designated "total institutions," such as prisons, the military, and psychiatric hospitals. These institutions aim to remake the individual through microscopic regulation that completely transforms her or his relationship with the world. One of the central features of these total institutions is absolutely rigid timetables that minutely control the individual's life-rhythms.

Timetabling is not, however, unique to total institutions in the contemporary world. Being on time is a central feature

of contemporary urban life, shaping our experience of the workplace, the school, the home, and many of our leisure activities. Time has been quantified and standardized. Clark Blaise (2000: 5) suggests that the development of standard time, a unified system of time measurement on a global scale, "is the ultimate expression of human control over the apparently random forces of nature." It is also the ultimate expression of the control of some humans over others.

E.P. Thompson (1993) argues that the increased dominance of clock-time was related to new forms of discipline associated with capitalist work relations, which regulated work by the clock rather than by the amount of time required to complete a task:

> Those who are employed experience a distinction between their employer's time and their "own" time. And the employer must *use* the time of his labour, and see it is not wasted: not the task but the value of time when reduced to money is dominant. Time is now currency: it is not passed but spent. (Thompson 1993: 359)

Thus, the modern factory system was oriented around clock-time. The operation of the factory was organized around a workforce who showed up at the same moment and worked until the end of their shifts. Before most individuals had their own watches or clocks, the factory bell was introduced to summon workers to their shifts; the school bell was developed soon after, to introduce children to the regime of time-discipline.

Thompson argues that the development of time-discipline was a specific strategy developed by employers to regulate the activities of working people rather than as a general necessity in a complex industrial society. Workers initially resisted this new regime of time-discipline, and it often took generations before it began to seem normal. Workers were used to living their lives according to different rhythms that seemed more natural and more autonomous, and did not take easily to being governed by the clock (see Thompson 1993: 394).

The historical development of time-discipline is relived biographically in every generation, as parents try to get kids to go to bed at a specified hour or ready for school or day-care in the morning. Children live in a land before time. Child-time is qualitative and non-standardized, as children make clear when adults try to tell them that time is up for an activity they are enjoying. They want to eat when they desire food and to do any activity only as long as it is engaging: "Are we there yet?" they cry.

Parents introduce children into time-discipline, preparing them for a society organized around clock-time. Over the past 30 years, the organization of children's lives around clock-time has become considerably more rigid as employed parents have become busier and attitudes have shifted to favour structured activities over free play (see Sears 2003: Chapter 7).

THE GREAT SPEED-UP

WE HAVE all become rather more bound up in the web of time because of the contemporary condition of speed-up. Science writer James Gleick (1999) makes an interesting case that the experience of time has accelerated in the light of technological innovation, particularly in the areas of communications and transportation. Humans can now communicate instantly across the vastest distances and move through space at a speed earlier generations could not have imagined. Electric light breaks the barrier of night while mechanical heating and cooling reduce the impact of the seasons except in specific areas of activity (such as farming or landscaping). The rhythms of life are increasingly detached from the cycles of nature and reoriented around the movements of the clock.

These movements of the clock have become ever more precise as technology has advanced, so that the seconds that were once regarded as a tiny measure are now broken up into

thousands of units. As minuscule measures of time (nanoseconds) become meaningful, we can scrutinize time use much more closely. As Gleick (1999: 6) writes; "We have reached the epoch of the nanosecond. This is the heyday of speed."

We who are living in this speed-up hardly notice it. Theoretical analysis allows us to reflect on this experience and ask questions about things that we usually do without thinking. It is not enough, however, to identify a speed-up; we must seek an explanation for it. As with the invention of the clock, I am setting aside the technological explanation that scientific advances in themselves account for the experience of speed-up. Rather, I want to relate speed-up to changes in the social arrangements between people.

A provocative discussion of the phenomenon of speed-up can be found in the work of Karl Marx. According to Marx, one of the defining characteristics of capitalist societies is the importance of ongoing market exchange. As more and more human products become commodities, things or services are made to be exchanged on the market. A generation ago, water was generally treated as a public utility in Canada and the United States. Now it is increasingly a commodity, bottled for sale in the corner store or sold by competing vendors to individual consumers.

The orientation of products towards the market has important implications for the experience of time. Marx (1977) argues in *Capital* that the market value of commodities is not arbitrary, but is based on the quantity of the one specific ingredient they all contain: a given quantity of labour, even if that is not listed in the ingredients on the side of the package. The way to value a car against a house or a ton of rice is to measure the amount of the one common ingredient in all of them: labour measured in units of time.

This means that it is a competitive advantage for corporations to minimize the amount of labour-time that is contained in a particular commodity. The product containing the least labour-time can generally be sold for the cheapest price. Corporations have invested tremendous resources in reducing the amount of labour-time contained in their products.

Indeed, the whole system of scientific management associated with mass production focusses on minimizing the labour-time contained in products by minutely regulating the way workers spend their time on the job.

Frederik Taylor was a pioneer in the development of scientific management around the end of the nineteenth century and the beginning of the twentieth. The social critic Harry Braverman (1974: 90) argues that the central thrust of Taylor's innovations was to dramatically increase management control over workers' moment-to-moment activities. Management was to acquire systematic knowledge of the labour process and use it to control every aspect of work, by the assembly-line method of breaking the whole operation into discrete tasks and establishing specific routines for the completion of each task. These routines were established using time and motion studies, in which the precise movements of the worker's body were documented and correlated to the detailed measurement of time required to complete tasks.

Scientific management was founded on the idea of speed-up. It has become a taken-for-granted feature of our modern life. Over the last 30 years, this speed-up has led to a tremendous time-squeeze that hits women most directly, given that they tend to bear the greatest responsibility for unpaid housework—child-rearing, cooking and cleaning, caring for aging relatives, shopping, and all the other activities that keep a household running—even when they are employed outside the home. Cutbacks in health and social services are making these duties even more onerous now. A study of the households of Hamilton steelworkers, for example, shows that women consistently do more housework than their spouses, in most cases at least double the amount (Livingstone and Asner 1996: 86-87). The combination of work, housework, and school leaves many of us overworked and starved for time.

Clock-time seems as natural as the sunrise when you have organized your life around it. But the predominance of clock-time is the product of very specific changes in social relations over the past 200 years. A time-line plotting the historical

Thinking Point: Fast Food

As discussed in Chapter 4, the process of evolution leads to the extinction of species that no longer have a place in a changing eco-system. Changes in the labour market also produce a form of extinction, often at a very high human cost for those who find that their jobs, and sometimes their whole occupation, has disappeared. One occupation that has moved onto the endangered list in my lifetime is the short-order cook.

The habitat for this species has not yet been completely eliminated. You can still find some traditional "greasy spoon" diners where the short-order cook is doing her or his stuff over a hot grill. Eggs are cooked to request, along with a variety of other meals, which, depending on the restaurant, might include burgers, home fries, grilled cheese sandwiches, pork chops, and a range of blue ribbon specials. The short-order cook needs to have a very specific set of skills to handle a large number of requests at the same time and prepare each item properly.

The traditional diner is, of course, rapidly losing ground to the advancing fast food chains. The staff at these fast food restaurants do not need to know anything about cooking. The work of food preparation has been broken into an assembly line of small tasks, each micro-managed by machines that indicate the precise amount of time required to complete the step. The beeping of the machine means that the person cooking does not need to know when the burger is done.

This detailed regulation by time dramatically reduces the skill requirements for the job, opening up a whole market of cheaper labour for the chain. Further, the micro-management of the labour process allows for very specific control over the work of employees. The short-order cook has some discretion in figuring out how to get things done as she or he is the expert on the ground. The staff at the fast food restaurant do not have such discretion and instead have their activities recorded in detail broken down into the smallest units of time.

The regulation of time, then, is a way of controlling our work right down to the smallest detail. The bar-code scanning machines at grocery stores provide management with a very specific account of what a certain cashier did over a given hour. Drivers for courier firms log every delivery on a computer device that provides a detailed time record of their activities. Computer and telecommunications technology have extended the regulation of time in many new directions.

changes in time use helps us step back from something that seems very obvious in the contemporary context and see how it got to be that way. In the next section, we will look specifically at the importance of historical notions of change over time in our understanding of the world around us.

IN MY theory classes, I often refer to historical events to establish a context in which to understand the development of particular theoretical schools. I often sense a groan in the class when we shift over to historical topics. I imagine at least some of the students rolling their eyes and saying to themselves, "Back in the day, when this professor was young and Beethoven was still alive and Rome was still an Empire and they didn't even have CDs ... "

Many people seem to think that they do not need to know much about history to understand the world. In this section, I'm going to try to persuade you that an historical imagination is absolutely essential to understanding our present society. We begin with the simplest idea: we cannot know the future. It is impossible to know what will happen in the next minute, let alone in days, weeks, or years.

We cannot know the future, yet we usually try to live every day as if we do. We make arrangements assuming that the sun will rise, the buses will run, and the people we treasure will be where we expect them to be when we expect them to be there. We act as if we know the future by making predictions based on the past.

In fact, all of our assumptions about the future are drawn from the past. It is only because these things have happened that we assume they will continue to happen. We generalize from the patterns of the past to generate expectations of the future. So, the only reliable information we have on the future is historical.

How do you decide what to pack for a weekend trip? You might check the weather report, but you can never really trust the long-term forecasts. Mainly you rely on past experiences. The place you are visiting at that time of year is likely to be warm or cold; you are likely to need to dress up for a celebratory event or not. I always pack an extra pair of pants because on one weekend trip, it poured rain. My pants got soaked, and I didn't have another pair with me. No one else had pants that fit me, so I had to sit around in a pair of borrowed pants that made me look ridiculous. Now I know that it is a false economy to save weight in my luggage by counting on wearing only the pants I have on; the weekend could include pouring rain and wet pants.

One of the things we all do as we get to know someone new is to find out what we can about their past. For example, if you are interested in a relationship with someone, it is interesting to find out a bit about their previous patterns. Have they left a trail of broken hearts? Have they ever had a relationship that lasted? Have they ever been single?

Pretty much any personal counselling you receive will involve some sort of discussion of your past. The classic version of Freudian psychotherapy is based on the strong conviction that you need to understand when and how particular patterns in your life were established. The answer to problems you now face with commitment, procrastination, or gambling addiction lie somewhere in the past when you established these patterns. The problem is that we are not fully conscious of the process through which our various patterns of living were established.

This biographical pattern of understanding the present and the future by understanding the past also applies to our examination of social relations. We need to understand how things got to be this way if we are to understand the way we live now and the possibilities for the future. James Baldwin (1985: 410) expresses this brilliantly:

> History, as nearly no one seems to know, is not merely
> something to be read. And it does not refer merely, or even

principally, to the past, On the contrary, the great force of
history comes from the fact that we carry it within us, are
unconsciously controlled by it in many ways, and history
is literally present in all we do.

At the individual level, it is fairly easy to understand that
we carry our history inside us and that it is present in the
things we do. The hurts and triumphs of our past shape our
feelings, expectations, knowledge, and motivations for what
lies ahead. I was humiliated by my performance in high
school gym class and tried to avoid anything that smelled of
sports for a long time after that. A friend of mine assumed he
could not do well in school, in part because of a teacher who
made fun of him in front of his class for spelling badly. Some
people end up reliving the patterns of their parents' relation-
ships, while others dedicate themselves to trying to do the
opposite. This is not necessarily conscious or intended.

The same thing happens at the level of society. Our life
course is framed by the historical development of the society
we live in. Our present world is the product of wars, natural
disasters, cultural developments, specific forms of inequal-
ity, economic boom and bust, and the movement of peoples.
Our standard of living; expectations of school, work, and
leisure; and social relationships are all the result of events in
the past. It matters in the automotive industry that workers
unionized through very difficult struggles in the 1930s and
1940s. Similarly, the pattern of work in the Canadian retail
sector depends in part on failed union drives or strikes at the
Eaton's chain of stores in the 1940s and 1980s.

As we become conscious of the ways the past has shaped
the present, we gain the capacity to shape the future. The prob-
lem is that we live in the present and are often not conscious
of how things got to be this way. We begin with the results of
the long process of historical development before our eyes.
Once a building is built, the whole process of construction is
hidden from us; we cannot see the foundations, the girders
that support the structure, or the pipes and wires that line the
insides. The same is true for our vision of society:

> Reflections on the forms of human life, hence also scien-
> tific analysis of those forms, takes a course directly op-
> posite to their real development. Reflection begins *post
> festum* [after the feast], and therefore with the results of
> the process of development ready to hand. (Marx 1977:
> 168)

Our understanding of society and our own lives is neces-
sarily retrospective. We look back from the present, which is
the latest moment in the process of development. We can un-
derstand the world around us only by asking how it got to be
this way. The influential nineteenth-century French sociolo-
gist Emile Durkheim states, "there is no sociology worthy of
the name that does not possess a historical character" (cited
in Frisby and Sayer 1986: 40-41).

C. Wright Mills (1959) argues that the great promise
of social science is that it might help people develop their
own capacities for the "sociological imagination," a way
of seeing the world that allows individuals to understand
their place within larger historical and social processes. He
writes, " ... the individual can understand his own experience
and gauge his own fate only by locating himself within his
period ... " (Mills 1959: 5). This sociological imagination
allows people to see how their own activity matters:

> By the fact of his living he contributes, however minutely,
> to the shaping of this society and to the course of its his-
> tory, even as he is made by society and by its historical
> push and shove. (Mills 1959: 6)

The sociological imagination allows us to understand not
only the forces that shape our world, but also the potential
for our own activity to change it. Mills argues strongly that
an historical vision is absolutely central to this endeavour.
Once we see particular forms of social inequality as the prod-
uct of particular historical developments, for example, we can
begin to understand what kind of remedy might be necessary.
James Baldwin (1985: 411) writes that white Americans in

his experience deny responsibility for racism and structural inequality in dialogue with African-Americans, saying "Do not blame me. I was not there." The challenge of a genuinely historical vision is that it reminds us that the past is not simply behind us, it is inside us in ways we often do not recognize.

Thinking Point: Your Own Historical Imagination

It is fairly easy to see on a personal scale that it matters how you got to where you are today. A person who has decided to undertake a post-secondary education after many years of full-time employment will see the classroom differently than a student arriving directly out of high school. Your sense of yourself in education is shaped by your triumph over the guidance counselor who told you that you would never make it to university, by your glorious "A" average in Grade 10, or by resisting the father who insisted that you had to study accounting as he had. You might have moved from a tiny town to be in a larger urban centre or stayed at home where you have always lived.

It can be more difficult to imagine how larger historical processes, particularly those outside of your own experience, have shaped the way you live today. The things you read in history books or see in museums may seem to be very removed from your own experience. A documentary film might bring it all to life a bit more, yet still not address the gap between the past and the life you live now.

Yet, the historical process that has led up to this moment has had a huge impact on the way you live. The education, jobs, health care, or leisure activities that are available to you now frame your expectations of life in ways you might not realize. It is quite a different experience, for example, to come to terms with being lesbian or gay in a situation where at least some of your basic rights have been recognized than it would have been in the 1950s or 1960s.

One of the best ways to find some sort of bridge between historical events and your own experience is to begin to investigate relatively recent occurrences—a big rock concert, a major sports triumph, an important strike, an election, an assassination, or a war—and speak to someone who was there. It makes a big difference hearing about such an event from someone who was there and then asking the questions you need to ask to understand it. I was fortunate enough to be able to interview the sisters and brothers of my grandparents about their experiences of migration to Canada

early in the twentieth century, and this has influenced my sense of myself ever since.

The aim, over time, is to be able to hone your imagination so that you begin to see, or at least wonder about, the past as it is still here with us. You ask what the original purpose of an older building was, or who used to live in a particular house, or why there are still cottages inside the park. Rather than simply being satisfied or dissatisfied with the education you receive, you might ask how it evolved. Universities, for example, developed as a form of elite education and have only more recently become accessible to people from a wider range of backgrounds. It is worth thinking how much that long history of elite education has shaped the post-secondary experience of today. Such an understanding will help clarify what kind of changes might be possible and how they might be accomplished.

WHOSE HISTORY?

THE SOCIOLOGICAL imagination, then, is the capacity to understand the influence of past development on our present activities and possibilities for the future. It is a crucial dimension of theoretical thinking, as it enables us to understand the forces that have shaped the world presented to our senses. The development of a historical vision as part of the sociological imagination is not simply a question of amassing facts about the past.

The reconstruction of the past is never a neutral activity; it is always done from some point of view, whether conscious or unconscious. You look at a photograph of yourself with a lover, for example, quite differently when the relationship is going well and after you have broken up. The story of how we came here looks different depending on the perspective of the teller.

In society, it is the powerful who most often control the reconstruction of the past. Most of us learn history through official versions taught in schools, remembered in monuments, presented in museums, or shown in movies or on television. Eric Hobsbawm (1983) describes the development of

these official versions of national history as the "invention of traditions." He argues that national governments got heavily into the business of developing an official version of the past in the face of militant working-class activism at the end of the nineteenth and beginning of the twentieth centuries. These official versions drew heavily on invented traditions that clothed emerging patterns of social organization in the garb of historical continuity and heritage.

This perception of historical continuity is particularly important to help maintain the power of the elite in the context of a capitalist society. Capitalism is a very disruptive social system, constantly reinventing itself with new technologies, work organization, and political conflicts. Firms grow or wither, countries prosper or suffer, empires wax or wane. Marx captures this disruptive character of capitalism quite poetically in the *Communist Manifesto*:

> All fixed, fast-frozen relations, with their train of ancient
> and venerable prejudices and opinions, are swept away,
> all new-formed ones become antiquated before they can
> ossify. All that is solid melts into air ... (Marx 1969: 111)

This disruption generally serves corporations well. Employers want to shake things up to drive up productivity and are not satisfied with the response that this is the way we have always done things. Products are sold as "new," "improved," even "revolutionary." But this disruption also poses a problem as those in power seek to maintain their positions. They might want to revolutionize our taste in underarm deodorants, but they also want us to respect the authority of the employer, the laws, the police, the politicians, and the bureaucrats. The invention of traditions contributes to the respect for authority by constructing a version of the past that legitimates it.

These invented traditions tend to make people more conservative, binding us to the way things are. The official version of history presents one's own country's military activity as always peacemaking, liberating, or defensive while those

of the other side are cast as war-mongering, repressive, and aggressive. The standard version of world history we learn in North American schools tends to justify an oppressive world order by reflecting a European perspective. The peoples of Africa, the Americas, Asia, or Australia are presented as "without a history" until they enter the story when they are colonized by Europeans (Wolf 1982).

As a result of what they learn in school, people of European ancestry tend to acquire ethnocentric ideas of cultural superiority. These ideas are often cleansed of the nastiest sorts of racism, yet carry with them assumptions about who makes things happen in history, and whose culture and science matter. Baldwin (1985: 410) argues that this produces an acceptance of the way things are and an inability to change:

> ... people who imagine that history flatters them (as it does, indeed, since they wrote it) are impaled on their history like a butterfly on a pin, and become incapable of seeing or changing themselves or their world.

Movements of the disadvantaged challenge these official histories as they gain momentum. The social movements of the 1960s, for example, unleashed a whole wave of histories from the perspective of women, workers, people of colour, and lesbians and gays. The stories of those "hidden from history" provide an important source of pride and help disadvantage people develop a sense of their capacity to change the world (see Rowbotham 1973; and Duberman, Chauncey, and Vicinus 1989). Baldwin (1985: 410) argues that there was an important historical dimension to his own process of becoming an advocate of freedom for African-Americans: "I am speaking as an historical creation which has had to bitterly contest its history, wrestle with it, and finally accept it in order to bring myself out of it" (Baldwin 1985: 410).

In schools, for example, we are not exposed to the history of North America from the perspective of the First Nations people who lived here when the Europeans arrived. It is true that the absolute omission of Aboriginal peoples has now

generally been corrected, so we no longer read about explorers entering the empty lands, sometimes guided by mysterious natives. But it is not enough to tell the story of the subjugation of Aboriginal peoples from a European perspective that makes it sound like an inevitable cost of progress. Our view of the world would expand substantially if we were to gain some sense of the ways of life of Aboriginal peoples and the experience of conquest and deliberate cultural destruction over time. The unsettling experience of rethinking the conquest of North America from First Nations' perspectives would necessarily raise important issues about the legitimacy of European domination and the claims of the nation-states produced through that historical process of subjugation.

TIME MACHINE

H.G. WELLS'S novel *The Time Machine*, published in 1895, explores the idea of travel through time. The main character in the novel, the Time Traveller, claims that it is as possible to move through time as through space, except that humans have not yet invented the means. At some level, he claims, we all time travel:

> For instance, if I am recalling an incident very vividly I go back to the instant of its occurrence: I become absent-minded, as you say. I jump back a moment. Of course, we have no means of staying back for any length of Time, any more than a savage or an animal has of staying six feet above the ground. (Wells 1983: 24)

The actual description of time travel in the book is quite vivid. As time accelerates, objects lose their solidity and liquify: "The whole surface of the earth seemed changed--melting and flowing under my eyes" (Wells 1983: 37).

We have moved no closer to implementing time travel in the years since Wells wrote his book. But we do know more

clearly now through the refinement of atomic theories that everything that seems solid is in fact in motion. The table top that appears so solid and fixed when you hit it is nothing but an arrangement of whirring atomic particles in constant motion.

The sociological imagination grounded in historical vision is crucial to our ability to recognize the relationship between solidity and movement at the scale of society. We cannot travel through time physically (except in one direction at a given pace), but we must do so intellectually through the activity of reconstructing the past if we hope to understand the present and gain some control over the future. It is only this historical vision, for example, that allows us to see that time itself is a social construction and not simply a natural phenomenon.

TIME TO DEBATE

O NE OF the most heated areas of debate in social theory is the interpretation of the historical process by which our present society developed. Conflict theories and social order theories present very different accounts of the rise of contemporary social relations, providing contending views of what is possible and desirable.

Interpretations of historical perspectives can naturalize our view of the social world we inhabit by presenting it as the only possible outcome of a process of development. Other visions are discounted as troublesome outbursts on the road to sensible social progress. At the same time, these interpretations can show the present world as only one of the possible outcomes of a contested past, and therefore one that is always open to further change. In this view, the outbursts along the way become an important record of the other possible futures people experienced on the way to the contemporary society.

As in previous chapters, as you read through this debate you should pay attention to the factors that align each argument with either the social order or the conflict model. One of the defining features of each of these models is a particular understanding of historical change that frames a vision of what is possible or desirable in the future.

Argument A: History is Progress

The society we live in now is the highest point in the historical process of human development. The general tendency through history has been one of improvement and innovation, even if at times the pace of change has been extremely slow. People have access to better and better knowledge of the world and, as a result, are able to improve society.

The idea of democracy, for example, arose in its earliest form in Athens in Ancient Greece. It took a long time for the idea of democracy to triumph, as it required a sufficiently open society for the interchange of discussion and debate to thrive. The rise of contemporary industrial society finally cast aside the despotism of rule by the nobility allied with a single official religion, bringing to the fore a new kind of leadership based on achievement rather than ascription.

The traditions of pre-industrial societies were crucial to the preservation of civilization, but were an obstacle to the flourishing of new ideas. New modes of scientific thinking, for example, were stifled by the single official religion that had been so important in maintaining elements of civilization up to that point. The rise of Protestantism played an important role in the opening of society, ending the monopoly of a single official church. It was only when scientific thinking was freed from its confinement that new technological and social advances could proceed.

The opening of society to new modes of scientific and philosophical thought is commonly referred to as the Enlightenment. It provided the basis for an industrial society based on the free exchange of goods and ideas. Democracy has proved to be the most effective system for the administration

of industrial societies as it allows for the expression of all points of view as a basis for the best decision possible. Other models of administration for industrial societies, such as the Soviet model, proved themselves to be untenable over time.

The current stage of globalization is a crucial one in the spread of modern industrial society around the world and for ongoing prosperity to reach the whole population of the planet. The free exchange of goods and ideas provides us with the basis for meeting the challenges we face in continuing the progress towards prosperity and the good life that we have made so far.

Argument B: Other Possible Worlds

Capitalism as a social and economic system developed in embryonic form in the cracks of the earlier feudal society. It required political revolutions, however, to get rid of the old feudal nobility and create the possibility for a fully capitalist society. The French Revolution that began in 1789 is perhaps the most famous of these, though it was in fact only one of many that swept across Europe and the Americas.

The French Revolution was an uprising that brought together the rising capitalist class and the crowd on the streets made up of employees and the poor (led largely by women). The capitalist employers and the crowd were united in the project of overthrowing the absolute monarchy and ending the stifling rule of the nobility. The rigid control of the nobility made it impossible to do business and denied the crowd any political expression of their dire condition.

The triumph of sweeping away the nobility was so great that the revolutionaries started the calendar all over again at the year one. However, lines of tension quickly arose between the capitalists and professionals on the one hand and the crowd on the other. Basically, capitalists and professionals argued that life should return to normal following the revolution, meaning that the crowd should basically accept its place in society and work hard under the supervision of the employers. Advocates for the crowd, on the other hand,

argued that this was the time to address historical injustices that had people on the streets so worked up in the first place. In the end, the capitalists triumphed. Throughout the 1800s, though, the working-class people of France rose up in periodic insurgency to demand the continuation of the revolution to develop a very different kind of society.

From the outset, then, the rule of the capitalists has faced the challenge of the crowd demanding another kind of society that addresses their historic grievances. Working-class people have contested this social system from the outset, often inspired by some version of socialism or anarchism. They have won a great deal by rising up to fight for their rights, including democratic enfranchisement, the right to form unions, and the establishment of social programs that offered at least some protection to at least some people against the ups and downs of the system.

The system is still contested. For example, we have seen mobilizations around the world to fight against the process of capitalist globalization that is designed to undercut the position of working-class people and the poor in the global economy. These struggles are a reminder that things might have turned out differently and still could.

Activity 4: Putting it All Together

The final activity is to construct a paper that makes an argument about the key contrast between the conflict and social order model approaches in the sample arguments above. You should begin by retracing your steps in the previous exercises: list the major points in each of the sample arguments above and connect them to the premises of the relevant model. Then chart the key points of contrast. Write a single paragraph that argues for the key issue that explains these points of contrast.

The final step in making this into a paper is to build subsequent paragraphs that tie the various specific points of contrast you have identified back to the key issue that differentiates the competing accounts. Each paragraph should

begin with a statement that links the discussion back to the major point identified in the first paragraph. Your final paragraph should return to the major point you made at the outset, showing how it has been elaborated through the rest of the paper.

Exercises

1. Keep a basic timecard on your activities for three days, tracking your major activities in one-hour slots. Write a brief paper on your experience of recording your own activities and what this told you about your control over your own time.

2. Is overwork increasing or decreasing? Start by recording your opinion before doing any research. Then find academic sources that might indicate whether or not overwork is increasing. Relate what you learned from the sources to your own opinion on the matter.

3. Try going for a whole day without wearing a watch. Keep a journal in which you record how this affected your experience of the day.

4. Plan a date for one week from today. What past experiences have allowed you to produce that plan? What assumptions are you making about the future?

5. In a small group, discuss the ways that time seems to pass more slowly or more quickly as you get older. Why does this happen? How can you explain it theoretically?

6

*Conclusion: So Many
Theories, So Little Time*

THEORETICAL THINKING provides use-
ful tools for making sense of the world around us. It allows
us to press beyond what we think we already know about
our environment, putting aside the fear of sounding silly and
asking the most naive questions about the way things work.
The preceding chapters have taken apart familiar concepts
(the classroom, reality, nature, and time) to demonstrate the
ways that theoretical thinking can reframe our understand-
ing of reality.

We have not yet penetrated very far into the tangled forest
of formal theories that influence scholarly work in the hu-
manities and social sciences. This forest can seem dense and
forbidding, as these formal theories appear to us as a set of
schools, overgrown and twisted together in endless debates.
It can be very difficult to find a way in, to recognize where
one tree ends and another begins.

This book recommends a method of tracing each tree
back to the ground, identifying how it is rooted in a few key
premises. The previous chapters have given you some expe-
rience in that method, using the debate between the social
order and conflict models as a recurring example. This has
provided a limited experience of engagement with formal
theory, but there are many more debates and models lurking
in the woods.

This final chapter is designed to equip you a bit better
for your engagement with the schools of formal theory that
frame contemporary theoretical thinking. The first section
will discuss the key features that distinguish formal theory
from everyday theoretical thinking. Formal theory must meet
a set of standards in areas such as logic and the use of ter-
minology, which is more rigorous than what we use in our

everyday thinking. These standards of rigour provide valuable criteria for assessing the powers of theoretical thinking and sharpening our own analysis.

Once we have a sense of the criteria that define what formal theory is, we can look at some debates about what it does. Specifically, we will examine the debate between those who argue that theory is a neutral tool for understanding the world and those who see it as a guide to action for social change. This debate offers some important insights into the divergent approaches to theorizing that make this area of study so contentious.

Finally, we will return to the conflict and social order models to emphasize how formal theoretical analysis flows from central premises. It really helps, when trying to make sense of theory, to develop your own compass that allows you to read theory in relation to a few fixed reference points derived from key debates. If you can begin to classify theories as you read them as conflict or social order or neither, it will help you make sense of the logic that links the various points each theory makes.

FROM THEORETICAL THINKING
TO FORMAL THEORIES

THE BASIS of theoretical thinking is to ask naive questions about how things work in the environment around you. As we answer the simplest questions (particularly why and how as opposed to who, where, and when), we are pushed to investigate the causal processes that shape the world we inhabit. At some level we all think theoretically when we speculate about the reasons things happen as they do. This reflection on the causes of things is absolutely essential as it is only when we can figure out what created a particular response at a specific moment that we can hope to repeat it with any predictability.

Thus, each of us works out our own vision of how things work through our daily lives. This is important, and it serves us well. Our insights can gain still greater power, however, when they are related to those of others that have been formulated into more rigorous theories and tested out over time. My own insights are quite adequate to tell me that this glass will fall to the ground and shatter if I let go of it. I will not, however, come to fully understand the workings of gravity on my own. I need access to the specialized thinking that has already developed in the area.

The more formal theoretical thinking associated with the social sciences adds a new level of discipline to our everyday theorizing. Competitive athletes must move beyond their own natural abilities and intuitive responses through specialized training grounded in a broader understanding of the mechanics of the human body and the advanced techniques in their particular sport. We can similarly train ourselves to develop more rigorous insights and greater powers of persuasion through engaging with the best theoretical analysis that is available.

Everyday theorizing is comparable to pick-up hockey or home cooking; to get to another level requires new skills learned through a range of specialized exercises and a great deal of practice. These skills can be learned, and like athletics some people probably have an easier time with them than others. I was always the worst in my class in gym, and I know that it was much more difficult for me to learn things that seemed like second nature to others. You may feel this way about the study of theory. However, all of us have the potential to think theoretically, and this can have an impact on our ability to act in the world.

Most of the time, we go through our lives simply accepting the world as it is. We do not seek explanations for the way things work. This attitude gets us through the day just fine. But it does hamper our ability to act in the world, to make changes. It is difficult to do very much about processes that seem to be shrouded in the cloak of mystery. Theoretical thinking can help us to pull back that cloak, moving from

Causation
why how

assuming that's just the way it is to asking why it is so. As we get to know the causes of things, we can begin doing something about them, whether that is understanding why some people get hired rather than others or figuring out why poverty persists in the midst of plenty in the contemporary world.

An engagement with formal theories is worthwhile when it take us beyond our own individual and at times eccentric interpretations of the world to some sort of common framework for discussion and debate. I might develop a personal insight that television makes children violent on the basis of seeing some play at wrestling after watching a particular show. That personal insight might not be enough to persuade others, who might treat the incident as unusual and atypical. My insight will have much more power if I relate it to existing debates on the subject as they are expressed through formal theories that meet rigorous criteria in such areas as logical consistency and fit with reality.

Five Characteristics of Formal Theorizing

1. Logical rigour
2. Empirical rigour
3. Conceptual rigour
4. Asks second-order questions
5. Relates to existing bodies of knowledge

There are five ways in which formal theorizing is more disciplined than everyday theoretical thinking.

1. *Logical rigour* provides a clear flow from the core assumptions of the theory to its detailed development. In everyday thinking we are allowed more slack. If we hold two beliefs that do not fit together, the people we argue with, for instance, in a bar, are unlikely to hold us up to the strictest standards of logic by pointing out the contradictions. In bars, people often try to win arguments by being bombastic, loud, and cranky. This kind of argument often ends up with

each person simply restating the same point again and again, barely listening to other points that might go against their own. I find that this kind of argument seldom moves me at all, as I am not challenged to reconsider the grounds of my own perspective by some systematic thought.

A disciplined logical approach can be a kind of mental judo, using the force of your opponents' own arguments to topple them. The aim is to clarify the foundations for claims being made and to ensure the quality of the links in the chain connecting each point to the next. You might argue, for example, that dogs are smarter than cats because you can train them to do all kings of things. A logical challenge to this point might ask whether it necessarily follows that obedience is a sign of intelligence. Might obedience not be a sign of stupidity as indicated by the lack of an independent will?

A good argument is disciplined by the standards of logical rigour. Formal theories are based on positions that flow logically from key premises. You can develop your own skills at logic through studying theory (as well as specific logic courses). This will make you more persuasive as you gain the ability to detect the weak points in other people's arguments and to anticipate the flaws others might detect in your own.

2. Theoretical thinking calls for *empirical rigour*. Although the theory may fit with what we know about the world, this does not mean that every aspect of every theory is immediately testable with observation and measurement. Einstein, for example, developed innovative theoretical statements that could not be tested definitively at the time. There are theories in physics that propose the existence of elements that are not visible even to the most sensitive instruments currently in use. We must ensure that such a theory is supported by the evidence that we have, and we must maintain the commitment to testing for indications that the theory fits the facts as we know them. In social theory we are always seeking some sort of match with the world out there.

Theoretical thinking without empirical investigation is speculation, the development of an explanation that could

speculation
not own
as theory

fit a particular case. Speculation can be extremely valuable, and it is an important feature of our everyday thinking. We often speculate about the causes of a particular phenomenon; for example, we try to figure out why a windshield wiper is not working well any more. The speculative explanation we come up with—the windshield and wiper blade are both dirty—might be adequate to meet our needs at the time, or it might not help. We will only know when we investigate further by trying the wipers after cleaning the windshield and blades.

More formal theory is based on a commitment to move beyond speculation into investigation. The fit between our explanation of the phenomenon and the actual flow of events is something that we can research. It is not enough to assert a connection between our speculative cause and the actual effect, we must do our best to demonstrate it.

On the other hand, empirical investigation without theoretical analysis is description, detailing the characteristics of the phenomenon without seeking an explanation. Journalism often tends to be descriptive rather than analytical. The news tells you what happened, but does not often try to explain in any depth the reasons why it happened. The supposed impartiality of journalism rests in part on the claim that it is the facts that get reported, though even so the facts are selected and arranged in ways that are far from neutral.

Social theory moves beyond description to analysis that asks challenging causal questions that cannot be answered at the level of the facts alone. If you follow the plot in any good detective novel, you will find the points where the crime-solver moves beyond the facts to analysis and theory. As a reader, I often get stuck at the level of the facts of the case and cannot put the picture together with theoretical thinking to figure out who did it.

3. Formal theories operate with great *conceptual rigour.* It is a standard feature of everyday language use that we employ words we do not fully understand because we have heard them in a context and think we know what they mean. That

usually works fine, though we have all probably been caught out at some time using a new word wrongly. In rigorous theoretical work, the words are the tools of the craft, and you must treat them with special attention. It is good to make friends with a dictionary as you work through social theory and at times to supplement that with a specialist source associated with the particular discipline you are working within.

This conceptual rigour is also reflected in the use of a specialized vocabulary that might seem quite alien. You will encounter words that mess with your brain a little. Your first response might be to feel that you are being jerked around by someone who has spent too many years in school and is using big words to show off and intimidate you. I would not deny for a second that many academics could benefit from enhancing their communication skills. But it is also true that specialized concepts can be developed as highly refined tools to work with great precision on the analysis of our social relations. For example, there are no simple everyday words to capture the meaning of "anomie," the idea of a society that leaves people without a clear sense of which norms to follow. A technical word is required to discuss a concept that has greater depth, precision, and generality than is normally present in a conversation.

4. These theories ask *second-order questions* that we do not usually bother with in everyday life. These questions step back from our direct interaction with the world (first-order) and focus on underlying questions about the nature of knowledge and character of existence. They ask, for example, how we know certain things. This can be at the simplest level, for example, a reflection on how I know it is raining outside right now. But it pushes far deeper to ask questions about how humans know the world around us. The discussion of the social construction of reality above was an example of a second-order question about the character of human knowledge.

Thinking Point: Disciplined Theorizing

Most of the time, we can afford to be a bit sloppy with our theoretical thinking. We can speculate to our heart's content about why the full moon looks extra big from time to time. The five aspects of more rigorous theory might seem to be a bunch of arbitrary rules designed to trip students up to in order to make it easy to give low grades. Personally, I am not a big fan of rules, and I love free thinking.

Formal theory and free thinking are not opposites. In fact, I firmly believe that engagement with formal theory can open up your thinking by providing you with access to new resources and new methods. The easiest way to understand this is to see whether writing you encounter day-to-day meets the standards that are laid out above. You might also use this as a way of assessing your own writing.

An easy first step is to take three newspaper articles and assess the extent to which they meet the standards of formal theory. These tools for critical reading help you form questions as you read through the material. Next try to read a more academic piece and assess it using the same standards. Finally, try to see how a piece of your own writing holds up. University professors often use some version of these five aspects of rigorous theory to assess student work.

5. At the level of formal theory we always *relate our own theoretical activity to existing bodies of knowledge*. In everyday theorizing we can dream up whatever explanation we like for a particular event. In contrast, in formal theory we either build on the foundation of existing theories or critique them to show their shortcomings. In this context, we do not begin from scratch, given that there have already been many attempts to explain whatever it is we are investigating.

CAN'T WE ALL GET ALONG?

We will now move from the general discussion of theoretical thinking to a focus on specific theories through the examination of a debate about the role of

theory itself. One of the major schools of thought in social science has tried to develop theory as part of an objective and detached scientific endeavour. In contrast, others see theory as a guide to action to change the world; they see objective and detached science as impossible and undesirable. This one debate will give some sense of the kind of debates that go on in the context of formal theorizing, where different theories often present contrasting explanations for the same phenomenon.

It can be very difficult to figure your way into the existing bodies of theory that one faces in the social sciences and humanities. They often seem to be very far removed from reality and so highly worked out as to be untouchable. Further, it can be a bit like stepping into a family feud where everyone wants you to take their side, and you cannot understand what the argument is all about.

I believe that the most fruitful approach to making sense of these debates is to try to understand the core assumptions about human nature, the way we know, or the character of the world that serve as a foundation for every major body of theory. The key premises of the conflict theory, for example, lead to a very different vision of globalization than those of the social order model. If you simply learn the fact that a conflict model theorist said one thing about globalization and a social order theorist said the opposite, you would still not have identified the core logic that links the perspective on globalization back to the cornerstone of the theory. Theories are far clearer when you understand that each rests on a key foundation that determines the shape of the whole structure.

It would be much easier if there were only one theory. Not that long ago in the discipline of sociology a thinker named Talcott Parsons set out to develop the one big theory that would unite the discipline. Parsons saw himself as performing a great synthesis that would bring together the best of all previously existing social theories by weaving together the threads of social theory that emerged in Europe in the nineteenth and early twentieth centuries.

The two towering European theorists Parsons based his work on were Max Weber and Emile Durkheim. Weber focussed on the study of purposeful social action, which requires an understanding of the motivations that lead people to act in certain ways. Durkheim focused on the need for moral regulation to achieve social order. Parsons brought the two together in a new theory that sought to understand the ways that our motivations are tied into the normative environment, so that our sense of why we do what we do is always connected to the broader values in our society (see Clarke 1982: 1-3; and Therborn 1976: 15-19).

Parsons argued this synthesis was based on the identification of common elements that were already there in the work of the theorists he examined. He described the book in which he first developed this synthesis as "a study in social *theory* not *theories*. Its interest is not in the separate and discrete propositions to be found in the works of these men, but in a *single* body of systematic theoretical reasoning" (Parsons 1968: xxi). He saw this theory as the foundation upon which a truly scientific sociology could be built.

This new synthesis was introduced as at a time when English-language traditions in sociology were not theoretically oriented. Parsons (1968: ix) remembered graduate studies at the renowned London School of Economics "without, as far as I can remember ever hearing the name Max Weber." The other giant of European sociology, Emile Durkheim, was known, "but the discussions were *overwhelmingly* negative."

Parsons introduced his new unified theory into a relative vacuum, and it quickly became the dominant perspective in English-language sociology. Indeed, the term "theory" was often used in the singular to indicate there was only one perspective and that was his own. People with other theoretical perspectives were largely marginalized. This domination lasted through the 1940s and 1950s, but was overturned in the 1960s. By the early 1970s, it was impossible to think in terms of a single overarching social theory rather than a series of contending theories.

The reason for this dramatic change was that the social movements of the 1960s and early 1970s opened up a whole series of political discussions and debates that could not help but have a huge influence on the social sciences. The anti-war, women's liberation, lesbian and gay, anti-racist, Québécois nationalist, Aboriginal, and third world freedom movements had a great transformative effect. The debates that raged through society made it impossible to claim, without being challenged, that theory was simply a technical matter not open to fundamental dispute.

The single unified theory of Parsons could dominate sociology only during the particular political circumstances of the Cold War period in which McCarthyism shut down many forms of dissent. McCarthy's anti-Communist witch hunt led to the firing of some radical academics and silenced others. It was possible to agree on a single theory in a situation where only a very small range of political opinion was expressible. The protests of the 1960s blew the lid off that narrow consensus.

There are many contending theories, then, because there are different political perspectives that demand expression when we investigate the social world. It might seem like this crowded field of theories results from the meaningless activities of too many academics in ivory towers with too little to do with their time. In fact, there are many theories because they actually matter; there are meaningful political differences between the schools of thought that dominate the social sciences and humanities.

One way of understanding these debates between contending theories is to see the contrast in their approach to theory itself. Each school of thought has very different perspectives on the role of theory in our understanding of the world around us. One of the dominant perspectives in the social sciences has seen theory as neutral, an unbiased tool for the objective examination of human circumstances. That perspective has been challenged historically by those who see theory as an important part of the struggle for social change, an instrument for identifying injustices and clarifying

strategies for combating inequities. An examination of these differences will help identify some of the points of debate that have led to the development of contending theoretical approaches.

THEORY AS NEUTRAL

Max Weber argued strongly for a distinction between politics and science. In the realm of politics, the goal was persuasion: "When speaking in a political meeting about democracy, one does not hide one's personal standpoint; indeed, to come out clearly and take a stand is one's damn duty" (Weber 1958: 145). In contrast, the goal of science was disinterested analysis. In a dispassionate analysis of democracy, for example, "one considers its various forms, analyzes them in the way they function, determines what results for the conditions of life the one form has as compared with the other ... " (Weber 1958: 145). Words are "swords against the enemy" in a political meeting, while in a scientific analysis they are "plowshares to loosen the soil of contemplative thought" (Weber 1958: 145).

Many other theorists support the distinction between politics and science proposed here by Weber. They seek to develop approaches to social science that are disengaged from the day-to-day practice of political persuasion. They claim to be able to separate facts from values in their pursuit of an accurate and unbiased way of understanding the human condition.

Emile Durkheim sought to establish the grounds for a truly objective social science in his book *The Rules of the Sociological Method*. In order to accomplish this, Durkheim (1964: 31) argued, "All preconceptions must be eradicated." A truly objective social science must begin with facts, approached objectively through sense data. The deep understanding of society means training ourselves to become disinterested observers totally detached from the things

we are investigating. Durkheim (1964: 143) wrote that his method was "dominated entirely by the idea that social facts are things and must be treated as such."

According to Durkheim, then, we must treat our social reality as a set of objects that we view from the outside with empirical rigour, distinct from our everyday experiences. Science must stand apart from our commonsense perspectives and develop a new set of concepts "that adequately express things as they actually are, and not as everyday life finds it useful to conceive them" (Durkheim 1964: 43). Science must "dismiss all lay notions and the terms expressing them, and return to sense perception, the primary and necessary substance underlying all concepts" (Durkheim 1964: 44).

The goal, then, was a new kind of theoretical understanding of society that was sharply demarcated from everyday assumptions and political advocacy in order to describe or interpret the world, not to change it:

> Sociology thus understood will be neither individualistic, communistic nor socialistic in the sense commonly given to those words. On principle it will ignore these theories, in which it could not recognize any scientific value, since they tend not to describe or interpret, but to reform, social organization. (Durkheim 1964: 142)

Theories must thus be "derived from facts and not from emotions" (Durkheim 1964: 143) so that situations can be analyzed neutrally to identify the specific causes of particular effects. Value judgements must be set aside to make this possible. Science must be concerned "only with facts, which all have the same value and interest for us; it observes and explains, but does not judge them" (Durkheim 1964: 47). The goal of such a science was to free us from partisanship:

> The role of sociology from this point of view must properly consist in emancipating us from all parties, not to the extent of negating all doctrine, but by persuading us to assume toward these questions a special attitude that

science alone can give with its direct contact with things.
(Durkheim 1964: 143)

Such a science could certainly have practical implications.
It would replace political advocacy inspired by particular
ideals with the clinical and scientific stance of the medical
doctor. Politics then becomes a technical matter, the effec-
tive diagnosis of the illness and a prescription for the correct
treatment. *Can you do this?*

> The duty of the statesman is no longer to push society
> toward an ideal that seems attractive to him, but his role
> is that of the physician: he prevents the outbreak of ill-
> nesses by good hygiene, and he seeks to cure them when
> they have appeared. (Durkheim 1964: 75)

This view presumed that it is both possible and desirable
to develop a scientific approach that is genuinely objective.
For example, in the 1940s Kingsley Davis and Wilbert E.
Moore (1970: 369) developed an analysis of social inequality
or stratification that suggested it was a universal feature of
human society that served to motivate people "to instill in
the proper individuals the desire to fill certain positions, and,
once in these positions, the desire to perform the duties at-
tached to them." In a debate with a critic, Davis (1970: 387)
argued that they were explaining stratification not justifying
it: "By insinuating that we are 'justifying' such inequality, he
falls into the usual error of regarding causal explanation of
something as a justification of it."

value neutral

The distinction between explanation and justification is
central to an approach to theory that seeks to set aside value
judgements and neutrally investigate the world that actually
exists. Davis (1970: 391) claimed that they were not "con-
cerned with the indefinite or utopian future but with societies
as we find them." The core claim of this approach to theoriz-
ing is: "just the facts." Theory offers explanations that can be
defined in specific observable terms and then tested against
the realities of "societies as we find them."

THEORY, FOR A CHANGE

THE POLAR opposite approach to theory explicitly rejects the goal of developing a neutral theory based on investigation of the world as it is. Rather, it aims to use theory as a guide to social action, informing people of the workings of the world so they can act to change. Karl Marx (1978: 123) put this bluntly: "The philosophers have only *interpreted* the world in various ways; the point is to *change* it."

From this perspective, a genuinely neutral theory is neither possible nor desirable. Brian Fay (1975: 94) argued that this approach is "built on the explicit recognition that social theory is interconnected with social practice." For instance, I find it hard to read the Davis and Moore theory that stratification motivates people without thinking of contemporary debates about social welfare programs, minimum wage levels, and security of employment. There are many on the right wing of the political spectrum today who support measures that increase the gap between rich and poor on the basis that it contributes to motivation for productivity. From my perspective, it is difficult to read the theory as neutral when it seems so clearly to relate to contemporary debates. At the same time, others reply that we can all benefit from a clear, disinterested analysis of our world.

Indeed, even the way Davis and Moore framed their claim for neutrality was politically charged. The assumption that we should exclude "the indefinite or utopian future" and focus on "societies as we find them" frames our understanding of the human condition within the limits of the way things are within the actual social relations of the contemporary world. Rather than examining how things got to be this way and how they might be different, it focusses our investigation on the way things work right now. We naturalize and eternalize by generalizing about the human condition from the way people act in particular circumstances within a specific social order.

In contrast, a theory oriented to social change examines the current state of society to see how inequality and injustice might be addressed through social action by those who are subordinated, who have a disadvantaged position inside dominant power relations. "A critical social theory is meant to inform and guide the activities of a class of dissatisfied actors ... " (Fay 1975: 97). In this view, theory can never be neutral as it is always understood in the context of social action to shape the future of society.

Above, I cited Durkheim's call for a strict distinction between social scientific and everyday understandings of the world. In contrast, the theory for social change begins with the actual knowledge of those who are subordinated. Nancy Harstock (1998: 222) argued, "We need a theory of power that recognizes that our practical daily activity contains an understanding of the world—subjugated perhaps, but present." The everyday theorizing we all do represents an important point of departure, not an impediment to understanding that is to be set aside.

At the same time, this theory is often not adequate in itself as it is based solely on the narrow parameters of our personal experience. As well, it is often affected by the dominant power relations in ways we do not consciously perceive. The power relations we live with day to day become integrated into our understanding of the way things work, so that we simply take for granted that the boss rules in the workplace and the teacher in the classroom. Our sense of what is possible is defined in relation to those apparently fixed points on our horizons. In other words, our common sense perspective often takes our place in the world for granted.

Theory for social change needs to go beyond that, pointing to the possibilities for freedom that are often difficult to see in the light of actual inequalities. It is very difficult day to day, for example, for workers to see beyond the power relations that currently structure the workplace or for women to envision a truly just gendered division of labour through the confines of restrictive household and work relationships. Yet, they do often have a sharp view of the inequities and daily

who?

create social change

social movements

operations of the current social order. Harstock (1998: 223) therefore suggested, "The critical steps are, first, using what we know about our lives as a basis for the critique of the dominant culture and, second, creating alternatives." There is a need for deeper theoretical work to uncover the workings of the system that are not immediately visible, even from below.

This deeper theoretical work is not simply the property of specialized theorists with lots of formal education. People engaged in trying to change the world through movements of the disadvantaged often actively engage in the analysis of their social environment. This often includes encounters with formal theory such as Marxism and feminism through various education activities ranging from study circles to cultural presentations.

The perspective of subordinated peoples provides a privileged, though partial, viewpoint that offers crucial insights into the workings of an unequal social order. According to Harstock (1998: 107), "women's lives make available a particular and privileged vantage point on male supremacy." The powerful have a uniquely partial perspective on the way the system operates since it generally seems to work pretty well for them. A man in a heterosexual couple, for example, might think he is carrying his share of the burden of housework if he puts his clothes in the laundry hamper rather than throwing them on the floor. A woman, on the other hand, might see what a small proportion of the everyday burden that little gesture represents, since she knows through her everyday experience that the heavy work of laundry is not getting the clothes into the hamper but sorting the loads, washing, drying, folding, ironing, and putting away. The less powerful actually see more of the way the whole system works than the privileged, who tend to take for granted that this is the way things are. The world really does look different through the window of a luxury car.

Those social scientists who think of themselves as strictly neutral might not be aware of the ways that dominant perspectives are integrated into their investigation of the world.

In contrast, those who use theory for social change bluntly declare their perspectives and do not claim to be impartial. However, if this theory is to genuinely lead to change, its actual fit with the world is very important. The ultimate test of theory in this case is practice, applying it to try to change the world. Marx (1978: 121) wrote, "Man must prove the truth, i.e., the reality and power ... of his thinking in practice."

This requires real rigour. It is not enough to simply recycle biases and restate claims that have no basis in reality. "If we are to construct a more just society, we need to be assured that some systematic knowledge about our world and ourselves is possible" (Harstock 1998: 222). This is, however, a very different approach to systematic knowledge than that of those who regard theory as neutral and seek to describe and interpret rather than change.

THEORY MATTERS

CERTAINLY, THIS discussion about the uses of theory does not exhaust the range of debate in the contemporary humanities and social sciences. The aim here is to provide an insight into why theoretical thinking matters. There is sharp debate even about the character of facts and their relationship of theory. As we have just seen, some theorists see theory as a crucial dimension in struggles to change the world while others aim for a genuinely impartial knowledge.

The impact of these differences becomes very clear if we return to the major issues discussed throughout this book. Our investigation of the classroom would look very different if it were seen to be an objective examination with an emphasis on testing observable phenomena rather than a critical analysis connected to the project of pursuing more equitable and democratic forms of education. The investigation of time is changed if one presumes it is related to domination and inequality as opposed to being a social fact to be studied in an objective manner. The idea of reality depends on whether

you believe that it is a set of objects outside of us to be investigated empirically or a set of social constructions reflecting the power inequities of the society we inhabit. Finally, those who want to use theory to change the world try to understand how naturalization encourages resignation by making the outcome of human agency seem determined by natural forces. On the other hand, those committed to an objective social science begin with assumptions that the social world can be investigated in the same way one could study nature, treating historical trends as the outcome of natural laws.

You are already a theorist at some level; we all are. Yet this everyday approach to generalization will only get you so far. You can become a much sharper and more self-aware thinker by engaging with the highly developed and sometimes hard-to-read formal theories associated with academic disciplines and movements for change. Your ability to make sense of the world around you is going to matter in your life, whether you aspire to change the world or to develop neutral or disinterested insights. Theoretical explanation offers a certain command over things that you do not have if you simply accept that the way things work is a mystery.

Why is inequality increasing? What causes violent crime? Why do wars happen? These issues affect your life, whatever perspective you take and however you choose to live it. The understanding of key theoretical debates about these topics is bound to provide you with both insights into the world around you and analytical skills that will improve the quality of your own everyday theorizing. Nevertheless, theoretical writing can be difficult to understand and can certainly be challenging to follow. There is, at least in theory, much at stake for you in these debates.

THE POLITICS OF SOCIAL THEORY

Social theory is highly contested. There are many theoretical positions on a particular topics

because there are many different visions of the way things are and should be in our society. As discussed in the previous chapters, the debate between the social order and conflict models is a defining one that has shaped and reshaped the humanities and social sciences. The 1960s, for example, saw a sharp rise in the focus on conflict theories in disciplines ranging from history to political science, from English to philosophy. The conflict model rose to a new prominence in many places as students radicalized by the social movements of the day challenged their professors and demanded new approaches. Feminism, for example, entered into the academic arena because women mobilized and challenged the prevailing male-dominated approaches in almost every discipline.

You have been challenged throughout this book to identify the underlying conflict or social order premises underlying conflicting positions on particular issues. This debate was chosen because it remains influential in some form or another across the range of humanities and social sciences. The analysis of this one debate also provided some experience in studying theory using a method that encourages you to seek out the founding premises of a theory and see how these are reflected in every position associated with that perspective. We will return to that debate here to show how these models differ even in their fundamental approach to theory.

The foundation of the social order model is the premise that moral regulation creates the possibility for a civilized society by restraining the greedy self-serving creature that lurks within all humans. The social institutions that shape and control us therefore act in the interest of all of us by creating a society in which orderly life is possible. Politics largely comes down to the technical question of how to solve any problems that might impede the development of shared values and thriving social institutions. Theory, then, is primarily an instrument for knowledge that can be seen as fundamentally neutral as it serves all of us by identifying with clear eyes the challenges facing our civilization.

In contrast, the conflict model is based on the premise that the existing society is based on fundamental inequalities that

create groups with conflicting interests who fight it out and produce social transformation. The social institutions that preserve the current order are therefore acting in the interests of the powerful, who benefit from the ongoing exploitation of the disadvantaged. Politics is the expression of the conflict in interests between the powerful and the subordinated groups who mobilize to fight back. Theory is a tool in this struggle, either serving the interests of the powerful by convincing us that fundamental change is impossible or serving the interests of the disadvantaged by mapping out the possibilities for change.

The contrast between these models might indeed have implications for how theory is taught and learned. In the social order perspective, where theory is seen as fundamentally neutral, it is a question of intellectual history, of understanding the process through which the leading-edge version of the best theoretical thinking developed. In so far as there is theoretical debate, it is taken as a sign of an immature science that has not yet produced the appropriate higher level theoretical synthesis that will provide a vision of the field that will unite us all, save for a few doubters cast to the outside.

According to the conflict model, on the other hand, the debates within the realm of social theory are the reflection of disputes between the powerful and the disadvantaged about how society should be run. In this case, it is a question of providing you with some navigational tools with which to situate yourself in these debates, which will continue as long as social inequality produces conflict. The claim that a single overarching theory could subsume these debates is ideological in the context of these conflicting interests in society.

You might, finally, want to situate this book in relation to these conflicting perspectives. There is some attempt at neutrality here in that positions from the conflict and social models were stated fairly (I hope) and given roughly equal weight at the end of each chapter. Yet, the logic of the book and the approach to understanding theory it suggests is derived primarily from one of these models. The ability to figure out the underlying theoretical logic of any piece you are reading

will serve you well in the study of theory and more broadly in negotiating the various forms of persuasion we all handle daily.

Exercises

1. Write a description of a workplace where you have been employed or some other place where you have done work within a set of dominant power relations. Consider the ways your own experience of work shapes your description of it. Imagine how it might look from the perspective of someone else in a very different position.

2. In a small group, watch a particular program on television this week. Each person should write a brief description of the episode, identifying the key characters, summarizing the plot lines, and evaluating the show overall. Compare notes and see what kinds of perspectives and assumptions led to differences in your descriptions. Discuss whether or not you think a genuinely impartial view of a television program is possible.

3. Get a copy of the Kingsley Davis and Wilbert E. Moore reading on social stratification discussed in this chapter. Write a one- to two-page journal response, noting your reaction to the reading. Does it strike you as neutral? Why or why not?

4. Do a library search to find an example of a social order or conflict model approach to one of the issues discussed above: the classroom, time, reality, or nature. Identify some of the crucial arguments in your source that reflect the key premises of the theory.

5. Find an article in your local newspaper and assess the ways it meets the five criteria for formal theory discussed in this chapter. Do the same analysis on a magazine article. Identify any differences between the two. Finally, compare these with an academic article from a scholarly journal. Once you have developed a three-way comparison, write a brief paper assessing the advantages and disadvantages of more formalized theory.

6. Write a paper in which you situate your own thinking in relation to the conflict and social order models. You might prefer one or the other, elements in both, or neither. Try to figure out how and why you have come to the position you now have on these debates. Do you think it is likely to change?

References

Alexander, Jeffrey. (1987). *Sociological Theory Since 1945*. London: Hutchinson.

Atwood, Margaret. (2000). *Negotiating with the Dead: A Writer on Writing*. Cambridge: Cambridge University Press.

Baldwin, James. (1985). "White Man's Guilt." In *The Price of the Ticket*. 409-14. New York, NY: St Martin's/Marek.

Bailey, Gordon, and Noga Gayle. (2003). *Ideology: Structuring Identities in Contemporary Life*. Peterborough, ON: Broadview Press.

Bannerji, Himani. (1995). *Thinking Through: Essays on Feminism, Marxism and Anti-Racism*. Toronto, ON: Women's Press.

Benjamin, Walter. (1999). *The Arcades Project*. Cambridge, MA: The Belknap Press of Harvard University Press.

Berger, John. (1972). *Ways of Seeing*. London: BBC Books; and Harmondsworth: Penguin Books.

Berger, Peter, and Thomas Luckmann. (1967). *The Social Construction of Reality*. Garden City, NY: Anchor.

Blaise, Clark. (2000). *Time Lord: The Remarkable Canadian Who Missed his Train and Changed the World*. Toronto, ON: Vintage Canada.

Brand, Dionne. (1998). *Bread Out of Stone*. Toronto, ON: Vintage Canada.

Brand, Dionne. (2001). *A Map to the Door of No Return*. Toronto, ON: Doubleday.

Braverman, Harry. (1974). *Labor and Monopoly Capital: The Degradation of Work in the Twentieth Century*. New York, NY: Monthly Review Press.

Brecht, Bertolt. (1964). *Brecht on Theatre*. Ed. and trans. John Willet. London: Methuen.

Carson, Rachel. (1962). *Silent Spring*. Boston, MA: Houghton Mifflin.

Cather, Willa. (1993). *O Pioneers!* New York, NY: Dover Publications.

Christopher, Nicholas. (2002). *Franklin Flyer*. New York, NY: Delta.

Clarke, Simon. (1982). *Marx, Marginalism and Modern Sociology*. London: Macmillan.

Davis, Kingsley. (1970). "Reply." In *Readings on Social Stratification*, ed. Melvin M. Turmin. 386-91. Englewood Cliffs, NJ: Prentice-Hall.

Davis, Kingsley, and Moore, Wilbert E. (1970). "Some Principles of Social Stratification." In *Readings on Social Stratification*, ed. Melvin M. Turmin. 368-78. Englewood Cliffs, NJ: Prentice-Hall.

Davis, Mike. (1992). *City of Quartz: Excavating the Future of Los Angeles*. New York, NY: Vintage Press.

Desmond, Adrian, and James Moore. (1991). *Darwin: The Life of a Tormented Evolutionist*. New York, NY: Norton.

Duberman, Martin Bauml, Martha Vicinus, and George Chauncey Jr. (1989). *Hidden from History: Reclaiming the Lesbian and Gay Past*. New York, NY: Penguin.

Durkheim, Emile. (1964). *The Rules of the Sociological Method*. New York, NY: The Free Press.

Durkheim, Emile. (1966). *Suicide*. New York, NY: The Free Press.

Eagleton, Terry. (1990). *The Significance of Theory*. Oxford: Blackwell.

Eagleton, Terry. (2000). *The Idea of Culture*. Oxford: Blackwell.

Fanon, Frantz. (1967). *Black Skin, White Masks*. New York, NY: Weidenfeld.

Fay, Brian. (1975). *Social Theory and Political Practice*. London: George Allen and Unwin.

Firth, Matthew, James Brophy, and Margaret Keith. (1997). *Workplace Roulette: Gambling with Cancer*. Toronto, ON: Between the Lines.

Fraser, Keath. (2002). *The Voice Gallery: Travels with a Glass Throat.* Toronto, ON: Thomas Allen.

Freire, Paulo. (1972). *Pedagogy of the Oppressed.* New York, NY: Herder and Herder.

Frisby, David, and Derek Sayer. (1986) *Society.* Chichester: Ellis Horwood; and London: Tavistock.

Galeano, Eduardo. (2001). *Upside Down: A Primer for the Looking-Glass World.* New York, NY: Picador.

Garfinkel, Harold. (1967). *Studies in Ethnomethodology.* New York, NY: Prentice Hall.

Glass Julia. (2003). *Three Junes.* New York, NY: Anchor Books.

Gleick, James. (1999). *Faster.* New York, NY: Vintage.

Goffman, Erving. (1961) *Asylums: Essays on the Situation of Mental Patients and Other Inmates.* New York, NY: Doubleday.

Golding, William. (1958). *Lord of the Flies.* London: Faber and Faber.

Gordon, Lewis. (1995). *Fanon and the Crisis of European Man.* New York, NY: Routledge.

Gould, Stephen Jay. (1977). *Ever Since Darwin.* New York, NY: Norton.

Gould, Stephen Jay. (2000). "More Things in Heaven and Earth." In *Alas, Poor Darwin: Arguments Against Evolutionary Psychology*, ed. Hilary Rose and Steven Rose. 101-26. New York, NY: Harmony Books.

Gould, Stephen Jay. (2002). *I Have Landed: The End of a Beginning in Natural History.* New York, NY: Harmony.

Gramsci, Antonio. (1971). *Selections from the Prison Notebooks.* Ed. Quentin Hoare and Geoffrey Nowell Smith. New York, NY: International Publishers, 1971.

Grandin, Temple. (1995). *Thinking in Pictures: And Other Reports from My Life with Autism.* New York, NY: Doubleday.

Hall, Stuart. (1999a). "New Ethnicities." In *Stuart Hall: Critical Dialogues in Cultural Studies*, ed. David Morley and Kuan-Hsing Chen. 441-49. London: Routledge.

Hall, Stuart. (1999b). "The Problem of Ideology: Marxism Without Guarantees." In *Stuart Hall: Critical Dialogues in Cultural Studies*, ed. David Morley and Kuan-Hsing Chen. 25-46. London: Routledge.

Harris, Nigel. (1971). *Beliefs in Society: The Problem of Ideology*. London: Pelican.

Harstock, Nancy. (1998). *The Feminist Standpoint Revisited and Other Essays*. Boulder, CO: Westview Press.

Harvey, David. (2000). *Spaces of Hope*. Berkeley, CA: University of California Press.

Hobsbawm, Eric (1983) "Mass Producing Traditions: Europe 1870-1914." In *The Invention of Tradition*, ed. E Hobsbawm and T. Ranger. 263-307. Cambridge: Cambridge University Press.

Høeg, Peter. (1995). *Borderliners*. Toronto, ON: Seal.

Hyman, Richard. (1975). *Industrial Relations: A Marxist Introduction*. London: Macmillan.

Ionseco, Eugene. (1958). "The Bald Soprano." In *Four Plays*. 7-42. New York, NY: Grove Press.

Kelley, Robin D.G. (2002). *Freedom Dreams: The Black Radical Imagination*. Boston, MA: Beacon Press.

Levesque-Lopman, Louise. (1988). *Claiming Reality: Phenomenology and Women's Experience*. Totawa, NJ: Rowman and Littlefield.

Lévi-Strauss, Claude. (1969). *The Raw and the Cooked*. New York, NY: Harper and Row.

Livingstone, David, and Elizabeth Asner. (1996). "Feet in Both Camps: Household Classes, Divisions of Labour and Group Consciousness." In *Recast Dreams: Class and Gender Consciousness in Steeltown*, ed. David Livingstone and J. Marshall Magna. 72-99. Toronto, ON: Garamond.

Lloyd, David, and Paul Thomas. (1998). *Culture and the State*. London: Routledge.

Love and Rockets. (2002). *Earth Sun Moon*. Remastered. Beggars Banquet Records.

Marx, Karl. (1969). "Manifesto of the Communist Party." In *Selected Works*, ed. K. Marx and F. Engels. 98-137. Moscow: Progress.

Marx, Karl. (1977). *Capital*. Vol. 1. New York, NY: Vintage.

Marx, Karl. (1978). "Theses on Feuerbach." In *The German Ideology*, ed. K. Marx and F. Engels. 121-23. New York, NY: International Publishers.

Mills, C. Wright. (1959). *The Sociological Imagination*. New York, NY: Oxford University Press.

Ollman, Bertell. (1993). *Dialectical Investigations*. New York, NY: Routledge, Chapman and Hall.

Ortner, Sherry. (1974). "Is Female to Nature as Male is to Culture." In *Women, Culture and Society*, ed. Michelle Zimbalist Rosaldo and Louise Lamphere. 67-87. Stanford, CA: Stanford University Press.

Orwell, George. (1966). *Homage to Catalonia*. Harmondsworth: Penguin.

Oxford. (2001). *The New Oxford Dictionary of English*, ed. by Judy Pearsall. Oxford: Oxford University Press.

Parsons, Talcott. (1968). *Sociological Theory and Modern Society*. New York, NY: Free Press.

Piercy, Marge. (1979). *Woman on the Edge of Time*. London: Women's Press.

Provincial Committee on Aims and Objectives of Education in the Schools of Ontario. (1968). *Report*. Toronto, ON: Ontario Department of Education.

Proust, Marcel. (1999). *Swann's Way*. Trans. C.K. Scott Moncrieff. New York, NY: Penguin Putnam.

Rankin, Ian. (1999). *Dead Souls*. London: Orion.

Rowbotham, Sheila. (1973). *Hidden from History: 300 Years of Women's Oppression and the Fight Against It*. London: Pluto.

Schutz, Alfred. (1967). *The Phenomenology of the Social World*. Evanston, IL: Northwestern University Press.

Schutz, Alfred. (1978). "Some Structures of the Life-World." In *Phenomenology and Sociology*, ed. T. Luckmann. 257-74. Harmondsworth: Penguin.

Sears, Alan. (2003). *Retooling the Mind Factory*. Toronto, ON: Garamond.

Smith, Dorothy. (1990). "Women's Experience as a Radical Critique of Sociology." In *The Conceptual Practices of Power.* 11-30. Toronto, ON: University of Toronto Press.

Therborn, Goran. (1976). *Science, Class and Society; On the Formation of Sociology and Historical Materialism.* London: New Left Books.

Thompson, E.P. (1993). "Time, Work-Discipline and Industrial Capitalism." In *Customs in Common.* 352-403. New York, NY: New Press.

Weber, Max. (1958). "Science as a Vocation." In *From Max Weber: Essays in Sociology,* ed. H.H. Gerth and C. Wright Mills. 129-56. New York, NY: Galaxy Books.

Wells, H.G. (1983). *The Time Machine and the War of the Worlds.* New York: Ballantine Books.

Wolf, Eric. (1982). *Europe and the People Without History.* Berkeley, CA: University of California Press.

Wotherspoon, Terry. (1998). *The Sociology of Education in Canada: Critical Perspectives.* Toronto, ON: Oxford University Press.

Index

political dimensions, 22
theory
 definition, 19
 relation to fact and
 opinion, 19–22, 24
 in research process, 12
 role of, 145
 sources of, 50
 uses, 152
theory and common
 sense, 27
theory as guide to action
 for social change, 136,
 143, 145, 149–50,
 152–53, 155
 perspective of
 subordinated peoples,
 151
theory as neutral, 136,
 143, 145–48, 155
 "just the facts," 148
theory of gravity, 18
Third World, 36
Thomas, Paul, 46
Thompson, E.P., 115
Three Junes (Glass), 51
time
 child-time, 116
 clock-time, 111–12,
 114–15
 development of standard
 time, 115
 effect of technology on,
 116
 fast food, 119
 historical understanding,
 111
 labour-time, 117

natural cycles, 113
 as rooted in social
 relations, 111
 social construction, 17,
 112, 129
 speed-up, 116–18
 varying pace of, 112
time and motion stud-
 ies, 118
time-discipline, 115–16
time-lines, 120–25
Time Machine, The
 (Wells), 128
"total institutions"
 time in, 114
typification, 70

unified theory, 143
 dominance during Cold
 War, 145

vantage point, 54–55
voice
 finding your voice, 24–27

ways of knowing, 48–49
Weber, Max, 144
 distinction between
 politics and science,
 146
Wells, H.G., *Time
 Machine, The*, 128
*Woman on the Edge of
 Time* (Piercy)
 view of human nature in,
 94–95
women, 49. *See also* gender
 categorization